Frank Elgar

THE POST-IMPRESSIONISTS

PHAIDON

The author and publishers would like to thank all those museum authorities and private owners who have kindly allowed works in their possession to be reproduced.

Phaidon Press Limited, Littlegate House, St Ebbe's Street, Oxford
Published in the United States of America by E. P. Dutton, New York

First published 1977
© *1977 by Phaidon Press Limited*

ISBN 0 7148 1810 0

Library of Congress Catalog Card Number: 77-79686

Printed in Great Britain

THE POST-IMPRESSIONISTS

In one hectic decade (1866–76) the Impressionists broke with France's rigid academic artistic traditions and produced what have become this century's most widely admired paintings and works of art. But in the immediacy of that appeal – the bright colours, the joyful, easy subjects – the Impressionists' works also revealed their limitations. They were too light-weight, too informal, to satisfy for long the new generation of artists they inspired. In the words of the art historian E.H. Gombrich, their works increasingly seemed 'brilliant but messy'.

In 1878, one of the Impressionists, Paul Cézanne, announced his dissatisfaction with the movement. He was now determined, he said, 'to make of Impressionism something solid and durable like the art in the museums'. His dissatisfaction was mirrored in different ways by the other artists – Gauguin, Van Gogh, Seurat and Toulouse-Lautrec and their disciples – who are collectively known as Post-Impressionists and whose work forms the subject of this book.

'Post-Impressionism' was not, however, a school or a movement. A term first coined in 1910, it is used by art historians to describe the work of artists who – each in his own unique way – continued the revolution begun by the Impressionists. It is a useful label, however, because in a few brief years (the 1880s) their works—with their revelation of psychological depth, their new use of shape, colours and light, their exotic subject-matter—established the major elements of twentieth-century art.

As individuals, the major Post-Impressionists were solitaries. Cézanne could never settle in Paris, quarrelled with almost everyone, and eventually worked in isolation in Aix-en-Provence. Van Gogh retreated in two senses: physically, to hermit-like solitude in southern France; and mentally, into the recesses of his own tormented mind. Gauguin vanished to seek an artistic renaissance in the South Pacific. Seurat was dominated by his own peculiar obsession with the scientific theories of light; Lautrec was deformed, and barred by both his stature and his alcoholism from normal life.

Though there are, surprisingly, some threads that are common to their lives—a fascination with the simplicity of Japanese prints, a passionate dedication to their art, an urge to express a reality deeper than that of surface impressions—these are superficial resemblances. Each was an individualist, and each made a unique contribution to painting.

Cézanne, reacting against the 'messiness' of Impressionism, sought coherence and clarity of form. He achieved his effects with meticulous brushwork and angular shapes that simplified and explained his subject matter brilliantly—a success that led directly to the Cubism exemplified by Picasso. Van Gogh, who portrayed the simplest, least 'artistic' (in the traditional sense) objects, wrote into his chairs, branches and fields a personal intensity that had little to do with his subject-matter, but which did unprecedented justice to the turmoil of his own mind. Gauguin, who had begun as an Impressionist, became convinced that he risked becoming stylistically slick. His escape to Tahiti was a deliberate attempt to return to basics—to the peasant, the primitive, the barbaric. He ignored the traditional subtleties of moulding and dimension in his determination to be direct and simple with large, flat patches of strong colour. Seurat, seeking (like Cézanne) an enduring style, found a different solution. He analysed colour rather than form. Aware that all light is a mixture of the primary rainbow colours, he built pictures in a mosaic of

primaries that would—he hoped—come together in the mind to form a composite image. To do this—again like Cézanne—he simplified drastically, achieving with a complex technique an extraordinary combination of intense lighting and austere design. Lautrec's artistic view of the world was an extension of his personality: a noble spirit coping in its own way with a deformed body and a vice-ridden life-style. As subject-matter, he chose social dross, and his style expresses his insecurity with slickness and spontaneity.

From these individualistic contributions emerged the major art movements of the early twentieth century. From the Post-Impressionists' concentration on colour sprang the exuberant glorification of colour that characterized Fauvism, whose chief exponent was Matisse. Seurat's formal designs and Gauguin's 'Synthetism'—his aim to express the ideal image of objects by re-creating it in the artistic imagination—were major influences on the literary and artistic Symbolist movement. From Cézanne's experiments with geometric shapes sprang Cubism. Van Gogh and Lautrec, in their urge to portray personal and social stress, inspired Expressionism, which counts Kokoschka, Soutine, Munch and Picasso among its exponents. Moreover, each of these major artists had their disciples, most notable of whom were Gauguin's followers Bernard, de Haan and Denis, and Seurat's admirer Signac. Together, these artists gave to the West the artistic tools to cope with a fast-changing and violent century.

Paul Cézanne (1839–1906), born in Aix-en-Provence, became the most outstanding artistic innovator of the nineteenth century.

As a young man, Cézanne—who came from a middle-class banking family—was sent to the lycée (where the future novelist Emile Zola was one of his schoolmates) and enrolled at the law faculty in Aix-en-Provence in 1859, following his father's wish that he should enter a 'respectable' profession. He soon, however, showed far more interest in drawing than in his law studies and simultaneously began to take courses at the School of Design in Aix. Then, with the support of his mother and one of his sisters, he managed to overcome his father's objections to an artistic career, and in 1861 went to Paris. There he studied at the Académie Suisse and frequented the Louvre, paying particular attention to Caravaggio and Velazquez. He also ran into Emile Zola again, and, while attending classes, made the acquaintance of the Impressionist Armand Guillaumin, who introduced him to Camille Pissarro.

The hubbub of the big city did not suit Cézanne, however, and he returned to Aix, discouraged to the point of accepting a job in his father's bank. He concurrently painted a number of portraits and decorated the walls of the Jas de Bouffan, an estate his parents had bought in 1859.

Dissatisfied once again with Aix, Cézanne returned to Paris in November 1862 and began to frequent the Impressionists. Nevertheless, he much preferred the work of Courbet and Delacroix, as he felt himself to be a strongly sensual romantic; he advocated painting, as he said, 'with guts'. But nothing seemed to satisfy him fully, neither the work of his fellow painters nor his own. A pattern of irascible behaviour, accentuated by hypochondria, began to emerge. He quarrelled with newly found friends, broke with an older artist whose work he much admired, left Paris in disgust, returned out of curiosity, and retired once more to Aix, only to leave again. In the evenings, he would be seen at the Café Guerbois in Paris, which served as a meeting place for Zola, the novelist Léon Cladel, the critic Louis Edmond Duranty, Renoir, Manet and Sisley, and would then disappear for days and weeks at a time. In 1869 he met Hortense Fiquet, a young model, who followed him to L'Estaque in 1870, when he fled to evade the mobilization order that accompanied the outbreak of the Franco-Prussian war.

4

When the war was over, less than a year later, Cézanne returned once more to Paris. He was thirty-two years old and had not yet produced anything of particular interest, although his work clearly demonstrated a revolt against academic strictures; he had not begun to lay the groundwork for the revolutionary experiments of his maturity.

In 1872 Hortense Fiquet gave birth to a son, who was named after his father. Cézanne now settled for two years in Auvers-sur-Oise, where he worked with Guillaumin and Pissarro, and began to change his art. He stopped depending on the use of thick paint in muddy colours and on extravagantly distorted forms; his palette grew brighter, his touch became subtler and his composition gained in solidity. However, *House of the Hanged Man* (1873), *Dr Gachet's House* (1873) and *Landscape in Auvers*, which he exhibited in 1874 in the first Impressionist Salon, received their share of gibes and sarcasm. Cézanne painted only a few more Impressionist canvases.

Then in 1876 his true personality began to emerge. The light brush-strokes, division of tones, and experiments with effects of light disappeared, and he began to accentuate volume, to compose through manipulation of mass, and to perfect the unity of his compositions. In 1877 he took part in the third Impressionist exhibition, but with no more success than in 1874. He then abandoned the idea of the group show and spent the remainder of his life in solitude. He retired to Aix and remained in Provence, leaving only on a few indispensable trips to Paris, or to visit Renoir at La Roche-Guyon in 1883, or Victor Chocquet, an admirer, at Hattenville in 1886.

Cézanne married Hortense Fiquet in 1886, and two years later his father died, leaving him a handsome heritage. He had quarrelled with Zola, Monet and a number of other artists and although he maintained contact with Emile Bernard, Gauguin, and Van Gogh, their relationships were neither cordial nor trusting.

The onset of diabetes, which followed upon a series of public failures, accentuated his hypochondria. In 1894 the art patron Gustave Caillebotte died and left his estate—which contained many Impressionist works, among them a number of Cézanne's paintings—to the country; initially, it was insultingly rejected by the artistic Establishment, and was accepted (only in part) after a year of wrangling between museum officials and Renoir, the estate's executor. A year later the Parisian art dealer Ambroise Vollard organized Cézanne's first one-man show. Although these events served to enhance Cézanne's reputation among younger artists they revived the academicians' hostility towards him.

No period of his work, however, proved more fruitful and assured than the decade 1885–95. These were the years in which he produced a series of portraits of Madame Cézanne, the *Blue Vase* (1883–7), *Boy in the Red Waistcoat* (1890–5), *Mardi Gras* (1880), *The Card Players* (1890–92) and the many *Baigneurs* and *Baigneuses* which he treated as geometrical problems.

As the years passed Cézanne's lyricism intensified. In his paintings and admirable watercolours of Château-Noir and the Montagne Ste-Victoire (Plate 14), particularly the works done after 1900, he expressed himself wholly through the deployment of planes and colours. In 1905, after several years of work, he completed *Bathing Women* (Plate 46).

Cézanne's old age brought him certain compensations and rewards. The Salon des Indépendants accepted his work for the 1899, 1901 and 1902 exhibitions. He was given an entire exhibition room of his own at the Salon d'Automne in 1904, and painters, writers, and poets paid homage to his work. Nevertheless, he continued to live in silent isolation. This revolutionary artist was the most reactionary of citizens; he attended mass regularly, opposed the defenders of Dreyfus, whose wrongful imprisonment for treason became the *cause célèbre* of the age, and had enormous respect for authority and official honours—in short, for the Establishment. His marriage had been inspired by a sense of duty and he

repressed his passionate temperament from a sense of propriety as much as from modesty. He was violent and timid, gruff and kind, repressed and generous, cowardly and proud, convinced of his own superiority and nevertheless riddled with anxiety. The most perfectly balanced of painters was torn between a flair for improvisation and a will to organization, between the exaltation of the Baroque and the rigour of classicism. Such, in brief, was the man who opened up new horizons and determined the course of painting in the twentieth century. So radical was the change he wrought upon the rules of perception and language that the history of art can be divided into two chapters: before Cézanne and after him. 'I remain the primitive of the path I discovered,' he said.

Because he was more of a realist than the Impressionists and because he wished to transcend the raw data of the senses, Cézanne soon abandoned the Impressionists' devices. He attempted to build a world of a permanence and universality that would be ensured by form, colour and structure. Yet to realize this apparently traditional artistic ambition, he unhesitatingly eliminated from his canvases chiaroscuro, modelling, transitional colour values and perspective. He treated his figures like still-lifes, and structured the sky, sea, earth, and vegetation of the landscapes as firmly as rocks and houses. 'To treat nature in terms of the cylinder, sphere, and cone' was his desire (and that of the Cubists, who succeeded him). In order to suggest depth on the flat, two-dimensional canvas surface, Cézanne shifted the angles of vision, raised the horizon line when necessary, and cut horizontals with verticals and oblique lines.

Once the feeling of space had been thus obtained, the problem became one of rendering objects in the light that coloured them, with all its atmospheric modifications. Rejecting the conventions then prevalent, those of the Impressionists and those of classical painters, Cézanne made a discovery that was to have incalculable consequences. For natural light, with its variations traditionally rendered through degrees of light and shade, he substituted an invented light expressed through the use of pure colour. Shadow was eliminated and modelling was replaced by the juxtaposition of colour tones; values were rendered through chromatic relationships. This conception led Cézanne to a completely new interpretation of form and line, for, as he himself said, 'When colour is at its richest, form attains its plenitude.'

Cézanne thereby made of the painting an autonomous object, a complete and coherent world, a creation that owed nothing to literature, anecdote, psychology, or symbol. Consequently, he is at the source of almost every innovating movement of the twentieth century. He prepared the way for the Fauves and was the first of the Cubists; his late work influenced non-figurative paintings. Every modern artist is indebted to him, and if painters today seem to run with such speed, it was Cézanne who taught them to walk.

Vincent van Gogh (1853–90) spent the first sixteen years of his life in a plain house in a plain Dutch village, with a Calvinist minister and his wife. In that pious, narrow-minded household, no sign of his genius appeared. One of his uncles was an art dealer, who in 1869 got the boy a job with the Goupil Gallery in the Hague. Later Vincent went to work for the gallery's London branch, while his brother Theo, his junior by four years, was hired by the same firm in Brussels. An unhappy love affair affected Van Gogh very deeply at this time; he fell into a mood of dark depression and was wracked by religious torment. In 1875 he was sent to work for Goupil's main branch in Paris, but this change brought no relief, and after difficulties with both customers and management, Vincent was fired. He returned to England briefly, this time to teach in a school; by 1877 he was working as a clerk in a bookstore in the Dutch town of Dordrecht. Increasingly subject to crises of mysticism, Van Gogh went to Amsterdam to prepare for the entrance examination to the

theological seminary there. He failed, after which he abandoned his studies, returned to his parents' home, left again after a month and went to Brussels to attend a Protestant school. In November 1878, he arranged to be sent as a missionary to the Borinage region of Belgium, intending to bring its miners back to Christ. He taught their children, cared for the sick, gave away all his possessions, and sacrificed his comfort, sleep, and health, until his overzealous behaviour earned him the distrust of the miners and the enmity of the clergy. In July 1879, Van Gogh was dismissed, after which he lived in dire poverty for months on end, wandering about like a tramp, not daring to ask for help, while his religious vocation gradually gave way to an artistic one.

In 1880 Vincent began drawing figures of miners in the realistic style of François Millet. In October he moved to Brussels; Theo, who was now working for Goupil in Paris, sent him enough money to pay for a few lessons in anatomy and perspective. From April to December (Van Gogh's career was so swift that it must be followed month by month) he stayed in Etten, where his parents and sister were then living. His conflicts with his father were aggravated by his love for his cousin Kee. She rejected him heartlessly, and Vincent went to The Hague to work under the supervision of his painter-cousin, Anton Mauve. In January 1882, he took in a prostitute—ugly, alcoholic and pregnant—who for twenty long months was the object of all the tenderness he could give her. Needless to say, this experiment in affection was scarcely more successful than his earlier ones. Abandoned by God, rejected by women, Van Gogh sought solace for his injured pride in art. This chosen path, however, held many more misfortunes in store. He quarrelled with his father, who disapproved of his artistic intentions; he broke with Mauve; wandered along the coast, making drawings and paintings of seascapes and fishermen; and went to the moors of Drenthe, where he drew his inspiration from thatched cottages, hamlets, and the peasant folk. When his money ran out, Vincent sought refuge in the parsonage at Nuenen, where his father had just been appointed. He spent two years there, displaying a passion for his work that amazed those around him. A brief romance with a neighbour and the sudden death of his father in no way diminished the impetus of his work, as he busied himself with drawings of the parsonage garden, still-lifes, peasant men and women, and weavers. Soon he tackled oil painting with the same furious passion.

Van Gogh spent the winter of 1885 in Antwerp, attracted by the harbour and the wharfs, impressed by the grandiose paintings of Rubens, fascinated by the Japanese prints he discovered in a local shop. A new world of light and balance suddenly opened up before him. He produced only a few more canvases in the dark, sad style of Nuenen, and in February 1886, Vincent left for Paris, where he was welcomed by his brother Theo.

Vincent immediately enrolled in the studio of Fernand Cormon (1845–1924), and there struck up a friendship with Toulouse-Lautrec. Outside the school, Van Gogh experienced a great revelation when he viewed the works of the Impressionists. Using a brighter palette and broken brush-strokes, he painted views of Montmartre, and the suburbs, a few still-lifes, portraits, and, above all, self-portraits. Obsessed with Japanese prints, he copied three of them. During his twenty-month stay in Paris, he produced two hundred canvases in the heat of his enthusiasm. When winter set in, his creative fever subsided, and, acting on the advice of Toulouse-Lautrec, he departed for the warmth and sunlight of Arles on 20 February 1888.

Everything about Provence entranced Van Gogh: the blossoming almond trees, the smiling Arlesian girls, the Zouaves from the local barracks, the blue sky, the clearness of the air, and the colours flashing in the sun. 'This is the Orient!' he exclaimed in delight, and he set to work immediately. From that moment on, he abandoned Nordic realism and Parisian Impressionism. His hand had never been so sure as now, when all at once he

turned from his preoccupation with light to that of colour. Suddenly, Vincent's canvases sparkled with vermilion, emerald green, Prussian blue, and yellow—that sacred yellow emblematic of the sun. Over a period of fifteen months (February 1888 to May 1889), displaying a haste as feverish as it was deft, Van Gogh painted some two hundred canvases, including *Orchard in Blossom*, the *Drawbridge at Arles*, a *View of Arles with Irises*, the *Plain of La Crau, Boats on the Beach, Sunflowers* (Plate 36), and the *Café at Night*. Several of these subjects fired his enthusiasm so intensely that he returned to them several times. He painted two versions each of *Sunflowers* and the *Drawbridge at Arles*. Landscape followed upon landscape and one portrait succeeded another: the *Postman Roulin, Lieutenant Milliet, Madame Ginoux*, also called *L'Arlésienne, Armand Roulin*, and portraits of Vincent himself (Plate 28). His drawings, with their concise, incisive lines; his vigorously constructed paintings, vibrating with the most vivid colours; in short, everything that Vincent produced in Arles attests to his aspiration for order, health, and serenity—the very things that life denied him at a time when he was achieving them in his art.

Hardships and excesses, together with the arrival of Paul Gauguin in 1888 and the ensuing conflicts between the two artists, finally brought a climax: on 23 December, Van Gogh tried to strike Gauguin, and then cut off his own ear. Gauguin fled, Vincent was taken to the Arles hospital. Released two weeks later, he painted the two famous versions of his *Self-Portrait with a Severed Ear*, the portrait of *Doctor Rey*, and the *Old Willow Trees*, all at the beginning of 1889. He began to suffer from hallucinations. When the attacks grew more frequent, he was again interned in the Arles hospital and then, at his own request, in the asylum at Saint Rémy. Between attacks, Van Gogh worked: from that awful period date some one hundred and fifty paintings (e.g. Plate 41), in which the wavy lines, disjointed forms, and whirls are the signs of near delirium.

On 16 May 1890, Vincent left for Paris, where he found Theo married and a father. He soon felt like an intruder in his brother's home, and went to place himself under the care of Dr Paul-Ferdinand Gachet in Auvers-sur-Oise. At this time he painted the doctor's portrait and that of his landlady, *Mademoiselle Ravous*, as well as the *Church at Auvers*, the *Town Hall on Bastille Day*, and the *Crows over a Cornfield* (Plate 47). On 27 July 1890, Van Gogh shot himself in the chest with a pistol. On the 29th he died, with Theo by his bedside. Six months later his brother followed him to the grave, after going insane himself.

An unstable, hypersensitive epileptic, who fought to stave off the fatality of evil and the threat of chaos by hurling himself recklessly into art; a man of rare nobility and utter sincerity, who sought in vain for a meaning to life; an artist who tried to realize his dream of a superhuman absolute through the language of forms and colour—this was Vincent van Gogh. Although he invented no new forms, he discovered the expressive value of colour (yet we must not forget that he was also a great draughtsman). In so far as his art did at times serve his own emotional vehemence, Van Gogh may be regarded as the first Expressionist, and in so far as he extended the possibilities of chromaticism, he was the originator of Fauvism. Actually, Van Gogh's work was not so much the sublime result of his vision of reality as it was the product of a tormented mind straining to achieve something beyond the reach of mortal man, something the artist believed he could grasp finally by his acceptance of death.

Paul Gauguin (1848–1903) was the son of a Republican journalist, Clovis Gauguin, and of Aline Chazal, the daughter of Flora Tristan, an eccentric woman of letters. At the age of seventeen Gauguin joined the navy, and visited Rio de Janeiro and Bahia, Brazil, as well as Scandinavia. On the death of his mother in 1871, he joined a stockbroker's firm in Paris, where a fellow employee introduced him to painting. He proved an intelligent,

serious, and hard-working employee, and seemed to have embarked on a highly successful career. In 1873 he married Mette Sophie Gad, a young Danish woman of bourgeois background; they were to have five children. Gauguin then begun to frequent artistic circles and became a close friend of Camille Pissarro. His period of apprenticeship and groping was a short one. He took part in the Impressionist exhibitions of 1880, 1881 and 1882, then suddenly announced to his wife that he was leaving the Stock Exchange. Mette was horrified and relations between Gauguin and her became strained. She became very worried about the future, and decided to take the children and live with her parents in Copenhagen. Gauguin went with them, but he soon felt himself an intruder in his wife's family. In 1885 he returned to Paris with his son Clovis.

At this point Gauguin's life took a dramatic and irrevocable turn—the beginning of an adventure that was to have the saddest and most glorious end. He put Clovis in a boarding-school and in June 1886 set off for Brittany, where he spent the summer at Pont-Aven. The same year he met Van Gogh, with whose ideas he became closely involved. In 1887, with Charles Laval, he set sail for Martinique; but they soon fell ill and had to return to France. In 1888 Gauguin again visited Pont-Aven, where Émile Bernard, whom he had met two years earlier, was living. This meeting proved decisive: Gauguin broke with the Impressionists, whose claims to 'realism' he condemned, and formulated a new approach to painting. Bernard claimed these ideas to be his own, but it was Gauguin who practised them with all the assurance and authority of the head of a new school. He called for a return to simplified, solid, well-defined forms, lighting without shadows, and flat colours—techniques that were then frowned upon as attempts to free the artist from nature. One example of the new style is *The Vision after the Sermon* (Plate 3).

Gauguin summed up these principles in one word, Synthetism. As a system, it was very close to the Japanese aesthetic, which he discovered through Van Gogh during the two months he spent with his friend at Arles at the end of 1888. During his stay he also produced a number of paintings. In 1889 he exhibited at the Café Volpini. These were greeted with derision by the public, but they made a strong impression on young artists. Thus, when in April 1889 he returned to Pont-Aven, a dozen of them accompanied Gauguin and their group became known as the School of Pont-Aven. But Gauguin soon left this village, where there were too many tourists, and settled in an inn at Le Pouldu; he was followed by his most faithful companions, Charles Filiger, Armand Séguin, Isaac Meyer de Haan, Henry Moret, Maxime Maufra, and Paul Sérusier.

It was at Le Pouldu that Paul Gauguin became fully convinced of the aesthetic of Synthetism and its vision of the world, which was inspired by Japanese prints, medieval stained glass, folk imagery, and primitive sculpture—a view exemplified by his *Yellow Christ* (1889) and his *Portrait of a Woman with a Cézanne Still-Life* (1890). It was not by chance, therefore, that on his return to Paris in December 1890, Gauguin joined the Symbolist writers who met at the Café Voltaire. But literary circles and their endless talk, together with financial difficulties, exasperated him in the end and he began to yearn for the simplicity and innocence of the natural man. Heavily in debt and stripped of all his possessions, he set off on 4 April 1891 for Tahiti. But when he got to Papeete, he found a European society, with all its prejudices, pettiness, and vice. He went to live among the natives at Mataiéa. It was there that he painted some of his finest pictures, including *Woman with a Flower* (1891), *When Will You Marry?* (1892; Plate 13), and *The Spirit of the Dead Keeps Watch* (1892). Penniless and exhausted by worry and overwork, Gauguin returned to France in April 1893.

His uncle had died, leaving him about 10,000 francs, with which he set about enjoying himself. In a studio that he rented in Rue Vercingétorix, he organized riotous parties,

presided over by Annah, 'La Javanaise', whom he painted in an unforgettable portrait (Plate 24). Degas arranged an exhibition of Gauguin's Tahitian works at the Galerie Durand-Ruel (November 1893). Financially, this exhibition was a catastrophe, but it aroused the enthusiastic admiration of Pierre Bonnard, Édouard Vuillard, and Maurice Denis. A series of misfortunes (a last meeting with his wife in Copenhagen, the flight of Annah, who ran off with the contents of his studio) and boredom with life in Paris made Gauguin decide to return to the South Sea islands. A sale at the Hôtel Drouot proved disastrous. Nevertheless, he embarked for Tahiti and arrived there in July 1895.

He settled in the north of the island, in a hut, where he worked heroically. His health began to fail and in 1897 he had to enter a hospital. But he continued to paint and produced some of his finest masterpieces: *Nevermore* (1897), *Tahitian Women with Mango Blossoms* (1899), and *Where Do We Come From? What Are We? Where Are We Going?* (1897). His manuscript, *Noa-Noa*, appeared in the *Revue Blanche* (beginning 15 October 1897). Among a peaceful people, whose customs and rites he shared while remaining incapable of exorcizing his European memories and habits, Gauguin tried to kill himself. But his distressed condition in no way diminished the generosity of his feelings. Revolted by the attitude of the whites towards the natives, he published satirical papers that aroused the hostility of the local authorities. In August 1901, he settled at Fatu-Iwa, on Domimea, one of the Marquesas Islands, in a rustic dwelling that he called the House of Pleasure.

Although aged, exhausted, and sick, he continued to draw, engrave, paint, and sculpt. He also wrote down his impressions in a great many articles that were later published, and in some very moving letters to his best friends. He was hated by the island administration, by the bishops, and by the police, and was arrested on the slightest pretext. Exhausted through privation, and almost helpless, Gauguin died on 8 May 1903.

'I wanted to establish the right to dare to do anything,' he wrote. He dared to combat 'civilization' and its hypocrisies. He also dared to rebel against the traditional aesthetic; by returning to the vital sources of inspiration and language, he attained—through the immobility of his figures, the gravity of their attitudes, the systematic use of flat areas of colour—the solemn grandeur of ancient and primitive art. While in Paris artists continued to exploit a number of techniques such as impasto and dark tones, Gauguin rejected modelling, values, and linear perspective and its receding planes, in order to give his pictures a certain nobility and majesty and to arouse in the observer a religious feeling for life, a sort of terror before the Unknowable. 'For me the primitive is rejuvenation', he said. He himself brought fresh life to the art of painting; the Nabis—an influential group of painters and theorists, notably Bonnard, Vuillard and Félix Vallotton—felt his influence, and the Fauves were his direct descendants.

With his usual lucidity, Gauguin wrote on the day before his death: The public owes me nothing . . . but the painters who are profiting from this freedom today owe me something.' Indeed, they owed him more than that.

Georges Seurat (1859–91) was brought up in a devout middle-class family, and was inclined from earliest childhood to be serious-minded, proud, and reserved. In 1875 he began attending classes in a municipal drawing school—supplementing them by frequent visits to museums and libraries—and in 1878 entered the École des Beaux-Arts, where he studied for two years under Henri Lehmann (1814–82), a student and follower of J.A.D. Ingres. Seurat was a conscientious and disciplined student, and was far less impressed by the precepts of Classicism than by Delacroix's Romanticism and colour theories. This was the first sign of the ambiguity that later characterized his life and work; although his temperament was basically classical and he was naturally inclined to discipline, he

nevertheless bestowed his admiration upon Delacroix, in whose work he had found confirmation of the physical laws of colour as set forth in the treatise by the chemist Michel Eugène Chevreul, which influenced him profoundly. By the time he was eighteen, Seurat had already found the direction in which he was to work for the rest of his short life; he was obsessed by the theories of Chevreul and other scientists on the simultaneous contrast of colour and the influence of two juxtaposed colours on each other in the mind. Thus, small dots of blue and yellow are combined in perception and seen as uniform green. Using a style known as Pointillism in which dots of pure colour are applied with meticulous regularity, Seurat applied these theories to his paintings.

In November 1880, after completing a year's term of military service in Brest, he returned to Paris, where for two years he devoted himself exclusively to drawing, stressing the study of values, contrasts, and shading. In 1883 the Salon accepted his drawing of his friend, the painter Edmond-François Aman-Jean (1882). That same year he also began painting his first major composition, *Une Baignade* or *Bathers, Asnières* (1883–4, reworked *c.* 1887; Plate 10). Completed in his studio, this immense canvas was preceded by a great many sketches and drawings that had been freely executed in the open air. It was refused by the Salon of 1884, but was later exhibited in the first Salon of the Société des Artistes Indépendants, of which Seurat was a founding member. In the course of the first meetings of the Indépendants, he came to know Odilon Redon, Henri-Edmond Cross, Albert Dubois-Pillet, Charles Angrand, and Paul Signac. It was only with the latter two, however, that he developed a deep friendship. Signac immediately adopted Seurat's ideas, and they exchanged the results of their artistic experiments.

In 1884 Seurat began to do drawings and studies of landscapes and of the crowds in the park on the island of La Grande-Jatte, near Asnières. He was already contemplating a major work in which he intended to test his system of colours and complementaries. Because of his inflexible and methodical way of working, he accumulated reams of drawings and painted panels in the course of his preparatory work on the site. This was done in the mornings. He spent his afternoons and part of the evenings in his studio completing each section, applying touch after touch, spot after spot, and point after point, focusing all his attention on each brush-stroke.

Sunday Afternoon on the Ile de la Grande-Jatte (1885; Plate 11) created a scandal when Seurat presented it, together with six seascapes that he had brought back from Grandcamp in October 1885, at the last Impressionist exhibition in 1886. Apart from the Symbolist writers Emile Verhaeren and Félix Fénéon (who later became the commentator and supporter of those painters who, under Seurat's lofty and taciturn leadership, formed the Neoimpressionist group), the majority of the artists and critics reacted with indignation.

Seurat had experimented as a scientist with an optical law of colour effects; experiment, however, was not responsible for the comparably logical system of linear and spatial organization that he developed. It was in the use of the endless resources of line, formal structure, and architectonics that he displayed his creative genius. The austere interplay of verticals and horizontals in the *Grande-Jatte* gave it a reassuring sense of stability and permanence. He obtained the effect of depth, not through the use of perspective, but through the contrast of light and dark; through even, gradual shading; through the play of shadow around highlighted lines of intersection; and finally, through the subtle superposition of planes. Seurat used light, in which the Impressionists had diluted their objects, to define and delimit. Far from subordinating line to colour, he used it as a controlling factor, restoring simplicity and purity to line so that it could withstand the busy effect created by the pigmentation and the corrosive appearance of the stippling.

Seurat's line acts to give form its place within an architectonic composition, stripping as it is of the irrelevancies of anecdote and the details of appearance. If Seurat had relinquished the flicker of decomposed light, his work might have gained in vigour and monumental grandeur. Nevertheless, the majestic calm, the perfect balance, and the classical conception of the *Grande-Jatte* and of the important paintings that followed it— *La Parade* (1887–8; Plate 35), *Les Poseuses* (final version 1886–8; Plate 39), *Le Chahut* (1889–90), and the *Circus* (unfinished, 1890–1)—represent the victory of construction over analysis, of the permanent over the ephemeral, and of order over dispersion.

Seurat's summer visits to the ports of the Channel coast—Honfleur (1886), Port-en-Dessin (1888), Le Crotoy (1889), and Gravelines (1890)—inspired him to paint some extraordinary seascapes. However frugal their execution, however modest their lyricism, they radiate poetry and a sort of spiritualized emotion that is the emanation of his serene and noble soul. One is consequently entitled to imagine all that Seurat's work might have gained had he not died as a result of a severe infection at the age of thirty-two. He was a painter-theoretician, engaged in the most highly intellectualized kind of adventure, and sought from scientific method what other artists demand of instinct. He was a solitary, sober, secret, and rather mysterious man who stands as a confirmation of the possibility of art as a fruit of the intellect. Actually, science brought him only the certainties that his inventive mind needed; neither his intellectuality nor his theories managed to stifle his lively imagination, which broke through the limits imposed by will and emotional discipline.

In the twentieth century, the Cubists used his discoveries in organizing their own pictorial space, and Fernand Léger invoked Seurat's example to justify his personal, stricter interpretation of Cubism. Indeed, all the painters for whom creation is inseparable from organization, for whom freedom is indissociable from discipline and courage from reflection, follow Seurat's example.

Henri de Toulouse-Lautrec (1864–1901) was a descendant of the counts of Toulouse, who had acquired their title during Charlemagne's reign. He was a sickly but bright child, and spent his early years at his family's estate near Albi. In 1873 his parents moved to Paris, where he attended the Lycée Fontanes (now the Lycée Condorcet). Lautrec then continued his studies in Albi under his mother's vigilant and affectionate supervision. She recognized her son's talent for drawing and encouraged its development. Unfortunately, in two consecutive falls (1878 and 1879), he broke both his thighs and remained a cripple for the rest of his life. A dwarf, whose short legs could barely support his normal torso, with a head too large for the rest of his body, he grew into a grotesque little man, barred from the ordinary pleasures of life but determined to fight adversity.

In 1880 Lautrec had the good fortune to study under an extremely intelligent animal painter and family friend, René Princeteau (1844–1914). His first paintings—*Soldier Saddling His Horse* (1879), the *Falconer: Comte Alphonse de Toulouse-Lautrec* (1881), and *Comte Alphonse de Toulouse-Lautrec Driving his Four-in-Hand to Nice* (1881)—revealed his staggering virtuosity and precocious feeling for modern art. In 1881 he passed his *baccalaureat* examination in Toulouse. The following year in Paris he enrolled in Léon Bonnat's class, then (1883) in that of Fernand Cormon, where his classmates included Louis Anquetin (1861–1932), Emile Bernard, and Charles Laval. Bored with academic discipline and fascinated by the work of Edouard Manet and Edgar Degas, he cut most of Cormon's classes. It was there, nevertheless, in 1886, that he met Vincent van Gogh, of whom he did a pastel portrait. The two painters became friendly and Lautrec was influential in the Dutch painter's decision to leave Paris for Provence. In 1885 Lautrec decided to leave

home and live the life of a Montmartre artist in complete independence, frequenting its cafés and dance halls, and submitting to its corrupt pleasures. At the Moulin de la Galette, the Moulin Rouge, and at Aristide Bruant's cabaret, the Mirliton, he frequently spent whole nights drinking and sketching all sorts of music-hall stars and even royalty who had wandered astray into this demi-monde. By the time he was twenty-five he had already mastered his technique, as may be seen in *Dancing at the Moulin Rouge* (1890).

For a brief period (1886–7), Lautrec was influenced by the Impressionists, and he even exhibited with them in 1889 at the Salon des Indépendants. Nevertheless, after about 1888, his work took a direction quite different from that of Impressionism. In 1891 he designed his first posters, an art-form he mastered from the start. Their simplified forms, their bold, flat areas of colour, and their striking layouts had a decisive effect upon his painting. He still, of course, continued to do painting on canvas, but he became increasingly interested in the use of oil on cardboard. Using quick, sure brush-strokes and applying pure colour mixed with turpentine, he produced the dazzling series of pictures that have the spontaneity of sketches and the authority of oil paintings (e.g. *In the Bar*, Plate 43). During the 1890s he also contributed humorous drawings to such periodicals as *Le Rire*, *Le Courrier Français*, *Le Figaro*, *La Revue Blanche*, and *La Plume*. He illustrated books by writer friends, produced numerous lithographs, and decorated theatre programmes and restaurant menus—all with prodigious skill. In 1895 he visited London, and in 1896 Holland and Spain. In 1898 he returned to London for an exhibition of his works at the Goupil Gallery. Excessive drinking and the strain of night life had so deeply undermined his health that in 1899, on his return to Paris, he was committed to a clinic for disintoxication. While there he drew his famous series of circus scenes. Discharged as a result of a newspaper campaign, he divided his time between Paris, Arcachon in the Gironde, Bordeaux, Le Havre and the family castle at Malromé; yet he began drinking again and his health began to decline. Sensing that the end was in sight, he had himself transported to his mother's side at Malromé, where he died on 9 September 1901.

The dominant themes of Lautrec's painting—the actresses, clowns, dancers, Lesbians, the circus scenes, café-concerts, brothels, race tracks, in sum all the creatures and spectacles of a pleasure-loving Paris—are similar to those portrayed by Degas, who had considered Lautrec an equal. Lautrec's draughtsmanship is, however, swifter, more concise and more biting than that of Degas, his colour more sober and his movement swifter. Lautrec's style is more casual, less affected, and ultimately more assured than that of Degas. In spite of the triviality and futility of its subject-matter, it communicates the proud distinction, verve, and disillusionment behind which Lautrec masked his tragedy with touching reserve. Lautrec also outstripped Paul Gauguin's attempt at 'synthesis': his use of the arabesque was more than merely supple, firm and sensitive; it was completely unsentimental and unliterary. Like Degas, Gauguin, and Van Gogh, as well as many other painters of his generation, Lautrec learned a great deal from Japanese prints. This Japanese influence, combined with that of poster design, led him away from Impressionism and Symbolism in the direction of the monumental art of placards and panels, such as those with which he decorated La Goulue's booth at the Foire du Trône (1895). He invented a vocabulary of abbreviation, devised original layouts, made bold use of the diagonal, and used colour sparingly but very expressively, reducing it in his posters and prints to a few surfaces saturated with a pure red, blue, or yellow.

Lautrec described the life of vice without succumbing to maudlin sentimentality. He painted human depravity with a mordant sincerity, and with the distant compassion, objectivity, and taut elegance of a gentleman. His touch remained unfailingly light. He hid the secret of both his genius and his own humiliation with a jest.

List of Plates

1. PAUL CÉZANNE (1839–1906). *Self-portrait with Palette.* About 1885–7. 92 × 73 cm. Zürich, E.G. Bührle Foundation.

2. EMILE BERNARD (1868–1941). *Portrait of the Artist's Mother.* 1887. 53·3 × 63 cm. Amsterdam, Vincent Van Gogh Foundation.

3. PAUL GAUGUIN (1848–1903). *The Vision after the Sermon.* 1888. 74·4 × 93·1 cm. Edinburgh, National Gallery of Scotland.

4. ISAAC MEYER DE HAAN (1852–95). *Farmyard at Le Pouldu.* 73·7 × 93·3 cm. Otterlo, Rijksmuseum Kröller-Müller.

5. PAUL GAUGUIN (1848–1903). *Loss of Virginity.* 1890. 90 × 130 cm. Provincetown, Walter P. Chrysler Jr.

6. PAUL CÉZANNE (1839–1906). *Still-Life.* About 1877–9. 46 × 55 cm. Private Collection.

7. VINCENT VAN GOGH (1853–90). *Still-Life with Coffee Pot.* 1888. 65 × 81 cm. France, Marquis de Chabannes.

8. PAUL CÉZANNE (1839–1906). *Mountains seen from L'Estaque.* About 1883. 54 × 73 cm. Cardiff, National Gallery of Wales (Gwendolen E. Davies Bequest).

9. VINCENT VAN GOGH (1853–90). *Cornfield with Cypresses.* 1889. 77·1 × 90·9 cm. London, National Gallery.

10. GEORGES-PIERRE SEURAT (1859–91). *Bathers, Asnières.* 1883–4. 201 × 300 cm. London, National Gallery.

11. GEORGES-PIERRE SEURAT (1859–91). *Sunday Afternoon on the Ile de la Grande-Jatte.* 1883–5. 207 × 308 cm. Chicago Art Institute.

12. HENRI DE TOULOUSE-LAUTREC (1864–1901). *The Englishman at the Moulin Rouge.* 1892. Coloured Lithograph. 47 × 37·2 cm.

13. PAUL GAUGUIN (1848–1903). *When Will You Marry?* 1892. 101·5 × 77·5 cm. Basle, Kunstmuseum.

14. PAUL CÉZANNE (1839–1906). *Landscape with Viaduct: Montagne Sainte-Victoire.* About 1885–7. 65 × 82 cm. New York, Metropolitan Museum of Art (H.O. Havemeyer Collection).

15. VINCENT VAN GOGH (1853–90). *Market Gardens.* 1888. 72 × 92 cm. Amsterdam, Vincent van Gogh Museum.

16. PAUL GAUGUIN (1848–1903). *The Market.* 1892. 73 × 91·5 cm. Basle, Kunstmuseum.

17. MAURICE DENIS (1870–1943). *April.* 1892. 37·5 × 116·2 cm. Otterlo, Rijksmuseum Kröller-Müller.

18. HENRI DE TOULOUSE-LAUTREC (1864–1901). *At the Moulin Rouge.* 1892. 122·9 × 140·4 cm. Chicago Art Institute (Helen Birch Bartlett Memorial Collection).

19. VINCENT VAN GOGH (1853–90). *'La Berceuse' (Madame Roulin).* 92 × 73 cm. February 1889. Otterlo, Rijksmuseum Kröller-Müller.

20. EMILE BERNARD (1868–1941). *Self-Portrait Dedicated to Vincent van Gogh.* 46 × 54·9 cm. Amsterdam, Vincent van Gogh Museum.

21. PAUL GAUGUIN (1848–1903). *Near the Sea.* 1892. 67·9 × 91·5 cm. Washington DC, National Gallery of Art (Chester Dale Collection).

22. GEORGES-PIERRE SEURAT (1859–91). *The Bridge at Courbevoie.* 1886–7. 45·8 × 54·6 cm. London, Courtauld Institute.

23. GEORGES-PIERRE SEURAT (1859–91). *Sunday at Port-en-Bessin.* 1888. 66 × 82 cm. Otterlo, Rijksmuseum Kröller-Müller.

24. PAUL GAUGUIN (1848–1903). *Annah the Javanese.* 1893. 116 × 81 cm. Berne, Private Collection.

25. HENRI DE TOULOUSE-LAUTREC (1864–1901). *Divan Japonais.* Poster, 1893. 79·5 × 59·5 cm.

26. VINCENT VAN GOGH (1853–90). *La Mousmé.* 1888. 70 × 60 cm. Washington DC, National Gallery of Art (Chester Dale Collection).

27. PAUL CÉZANNE (1839–1906). *Portrait of Ambrose Vollard.* 1899. 100 × 81 cm. Paris, Louvre.

28. VINCENT VAN GOGH (1853–90). *Self-portrait.* 1888. 65 × 51 cm. Vincent van Gogh Museum, Amsterdam.

29. PAUL GAUGUIN 1848–1903). *Self-portrait with Palette.* 1893. 55 × 46 cm. Los Angeles, Mr & Mrs Norton Simon.

30. HENRI DE TOULOUSE-LAUTREC (1864–1901). *Oscar Wilde.* 1895. 58·5 × 47 cm. Vienna, Dr & Mrs Conrad H. Lester.

31. PAUL CÉZANNE (1839–1906). *Man Smoking a Pipe.* About 1892. 73 × 59·6 cm. London, Courtauld Institute.

32. PAUL GAUGUIN (1849–1903). *The Day of God.* 1894. 69·6 × 89·9 cm. Chicago Art Institute (Helen Birch Bartlett Memorial Collection).

33. GEORGES-PIERRE SEURAT (1859–91). *The Seine at Courbevoie.* About 1885–6. 81·5 × 65 cm. Paris, Private Collection.

34. HENRI DE TOULOUSE-LAUTREC (1864–1901). *Salon in the Rue des Moulins.* 1894. 111·5 × 132·5 cm. Albi, Musée Toulouse-Lautrec.

35. GEORGES-PIERRE SEURAT (1859–91). *La Parade*. 1887–8. 99·7 × 150 cm. New York, Metropolitan Museum of Art.

36. VINCENT VAN GOGH (1853–90). *Sunflowers*. 1888. 93 × 73 cm. London, National Gallery.

37. VINCENT VAN GOGH (1853–90). *Dr. Gachet*. 1890. 66 × 57 cm. New York, S. Kramarsky Trust Fund.

38. HENRI DE TOULOUSE-LAUTREC (1864–1901). *Dance at Moulin Rouge*. 1890. 115 × 150 cm. Philadelphia, Henry McIlhenny.

39. GEORGES-PIERRE SEURAT (1859–91). *Les Poseuses*. 1888. 39·4 × 48·9 cm. Luxembourg, Artemis S.A.

40. PAUL CÉZANNE (1839–1906). *Still-Life with a Teapot*. About 1899. Cardiff, National Gallery of Wales.

41. VINCENT VAN GOGH (1853–90). *Van Gogh's Bedroom at Arles*. 1889. 72 × 90 cm. Amsterdam, Vincent van Gogh Museum.

42. PAUL CÉZANNE (1839–1906). *The Woman with the Coffee Pot*. About 1890–4. 130 × 96 cm. Paris, Louvre.

43. HENRI DE TOULOUSE-LAUTREC (1864–1901). *In the Bar*. 1898. 81·5 × 60 cm. Zürich, Kunsthaus.

44. GEORGES-PIERRE SEURAT (1859–91). *La Poudreuse*. Probably 1889–90. 94·5 × 79·2 cm. London, Courtauld Institute.

45. HENRI DE TOULOUSE-LAUTREC (1864–1901). *Clowness Cha-u-ka-o*. 1895. 81 × 60 cm. Cannes, Mrs Frank J. Gould.

46. PAUL CÉZANNE (1839–1906). *Bathing Women*. About 1900–5. 130 × 193 cm. London, National Gallery.

47. VINCENT VAN GOGH (1853–90). *Crows over a Cornfield*. 1890. 50 × 100 cm. Amsterdam, Vincent van Gogh Museum.

48. PAUL GAUGUIN (1848–1903). *Contes Barbares*. 1902. 130 × 91·5 cm. Essen, Folkwang Museum.

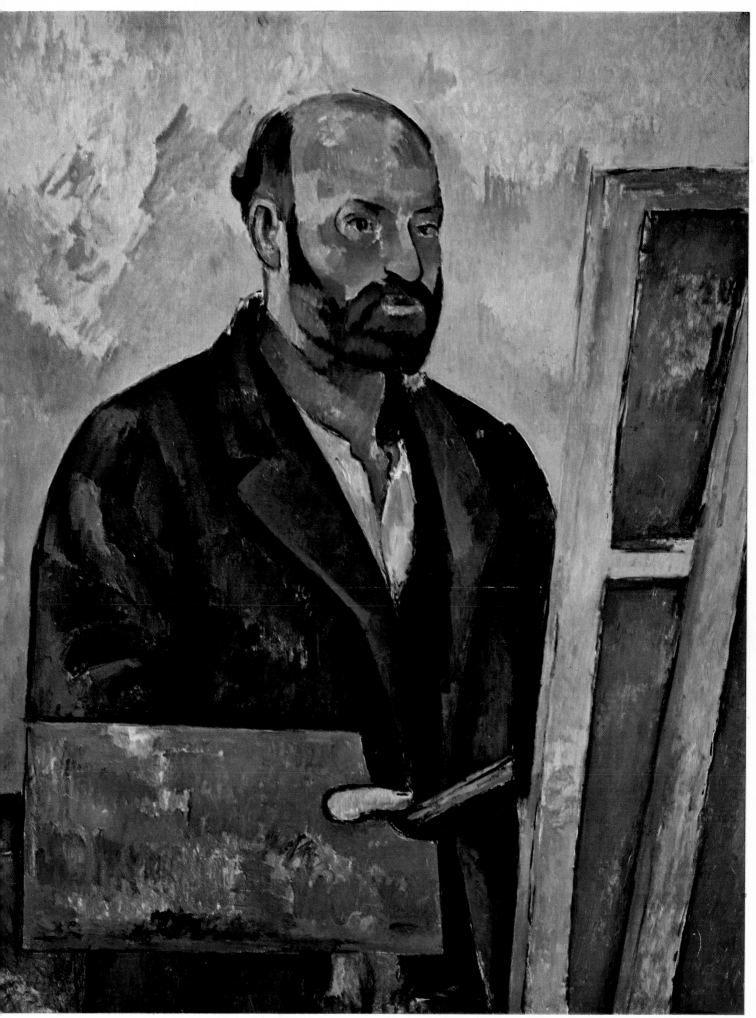

PAUL CÉZANNE (1839–1906). *Self-portrait with Palette.* About 1885–7. Zürich, E.G. Bührle Foundation

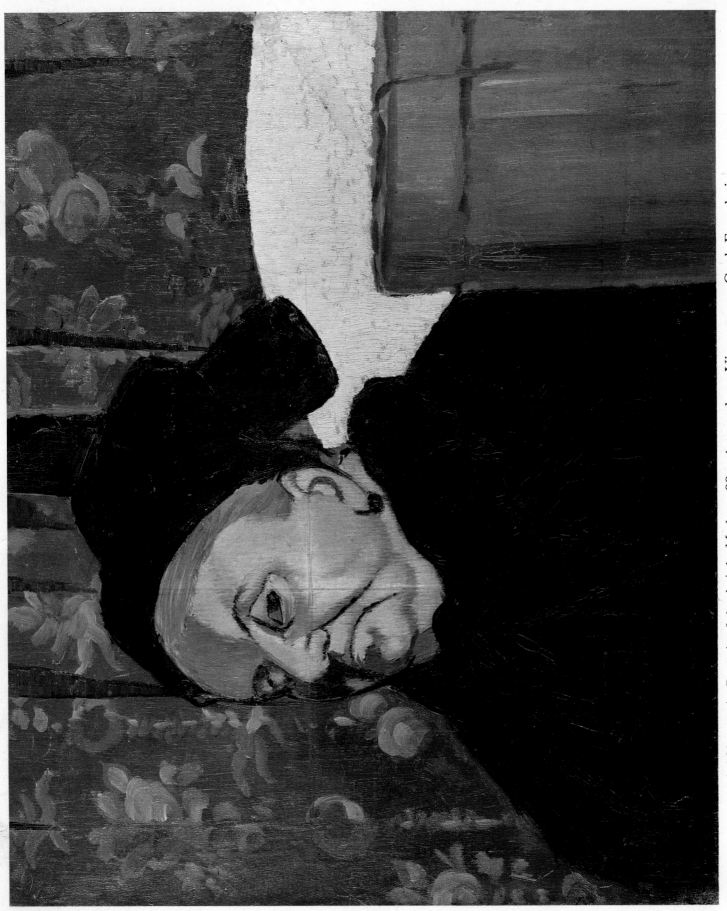

2. EMILE BERNARD (1868–1941). *Portrait of the Artist's Mother.* 1887. Amsterdam, Vincent van Gogh Foundation

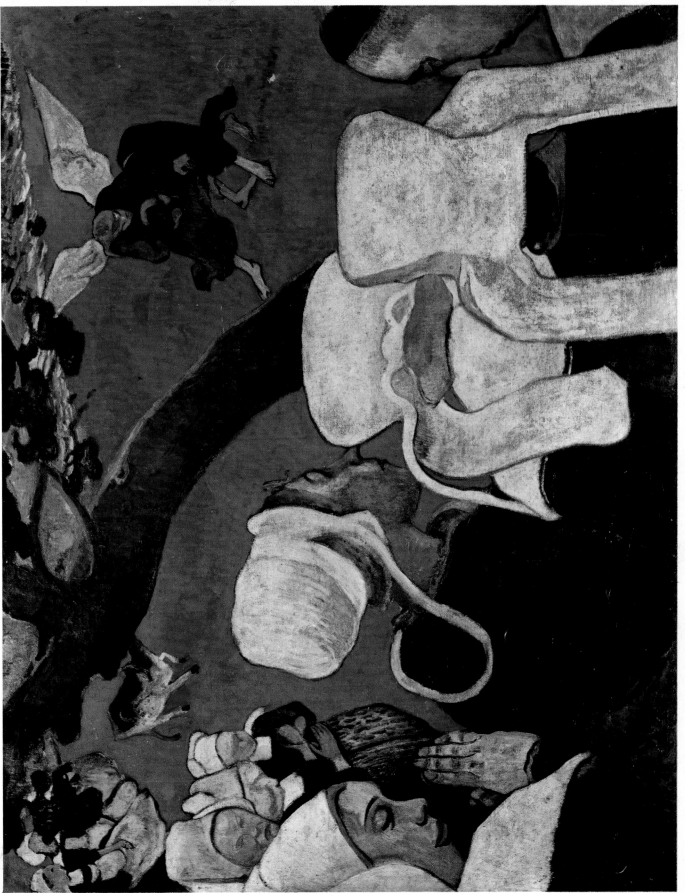

3. PAUL GAUGUIN (1848–1903). *The Vision after the Sermon.* 1888. Edinburgh, National Gallery of Scotland

4. ISAAC MEYER DE HAAN (1852–95). *Farmyard at Le Pouldu*. Otterlo, Rijksmuseum Kröller-Müller

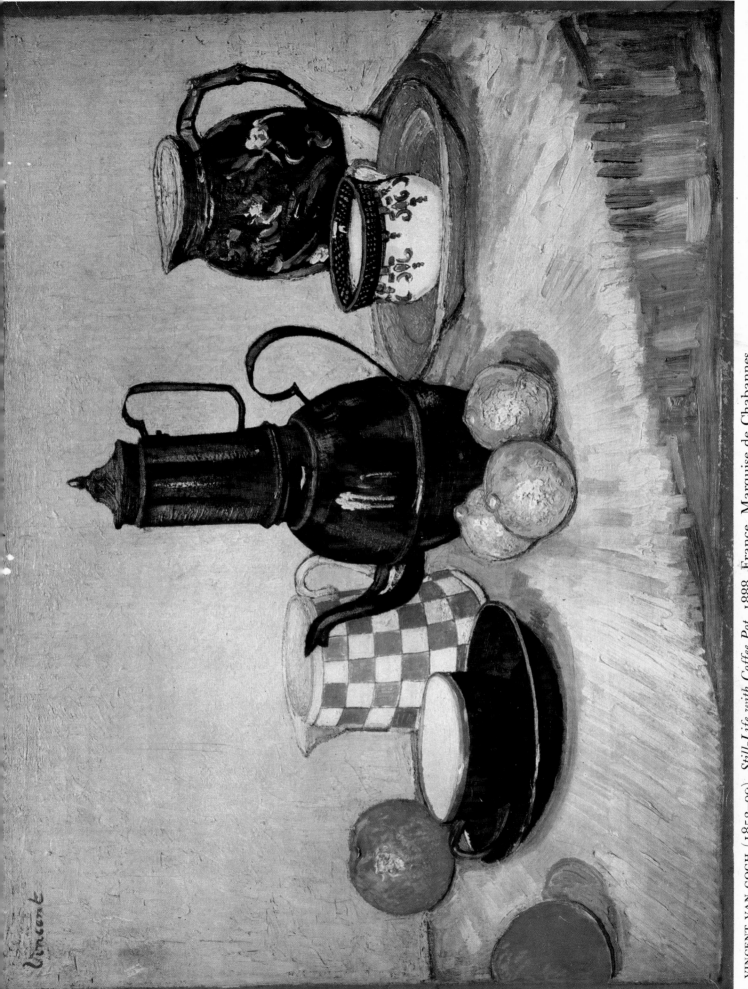

7. VINCENT VAN GOGH (1853–90). *Still-Life with Coffee Pot*. 1888. France, Marquise de Chabannes

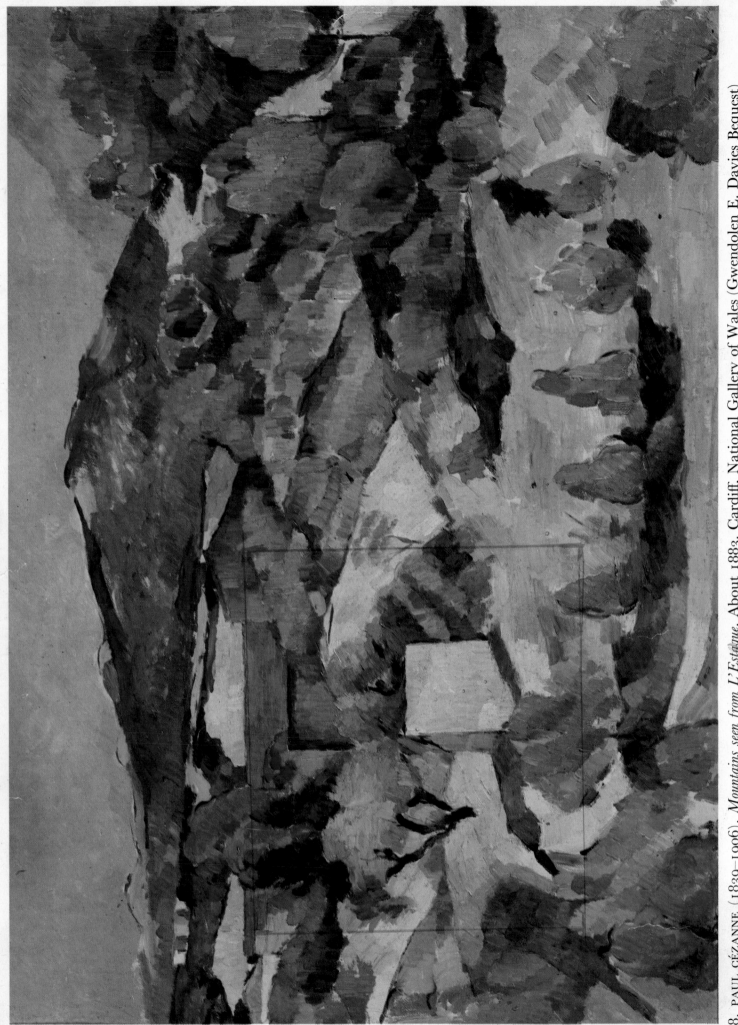

8. PAUL CÉZANNE (1839–1906). *Mountains seen from L'Estaque*. About 1883. Cardiff, National Gallery of Wales (Gwendolen E. Davies Bequest)

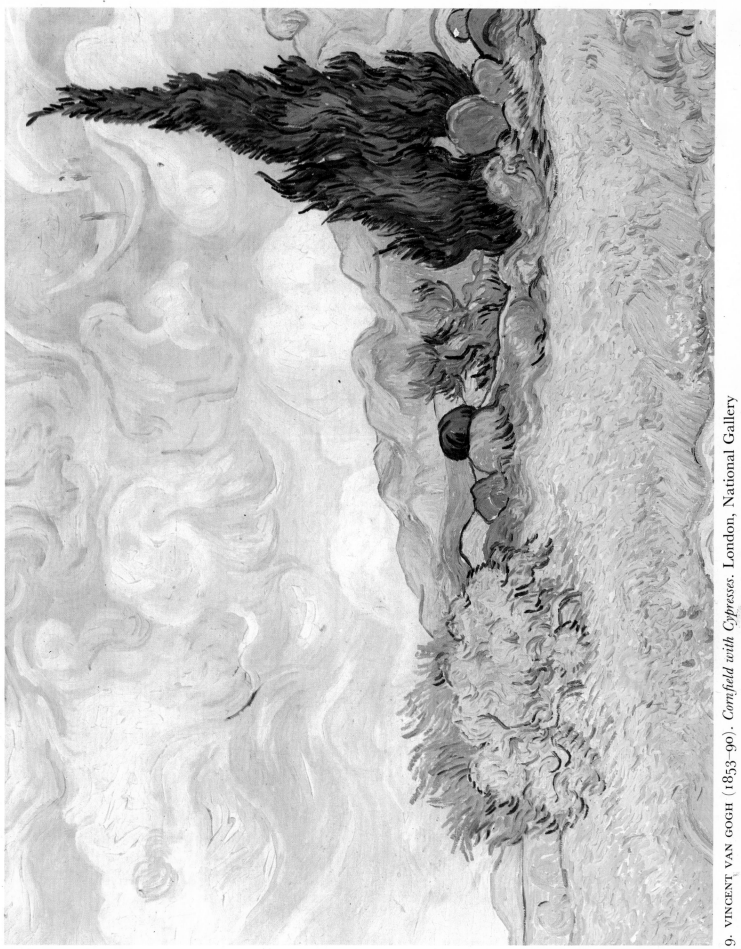

9. VINCENT VAN GOGH (1853–90). *Cornfield with Cypresses*. London, National Gallery

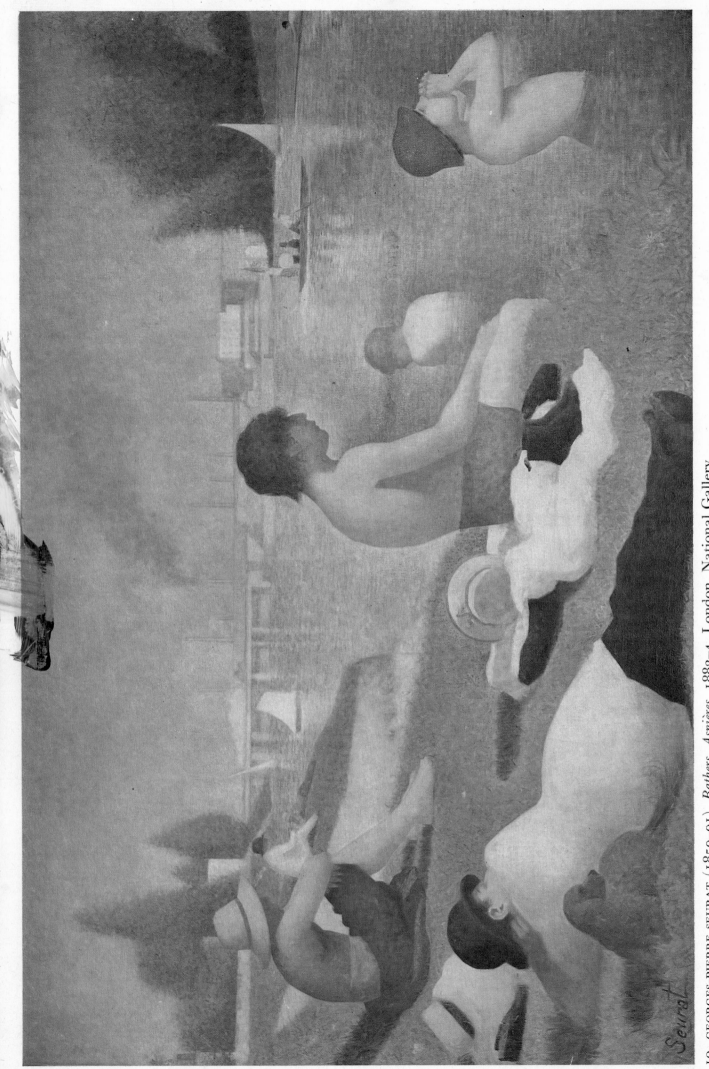

10. GEORGES-PIERRE SEURAT (1859–91). *Bathers, Asnières.* 1883–4. London, National Gallery

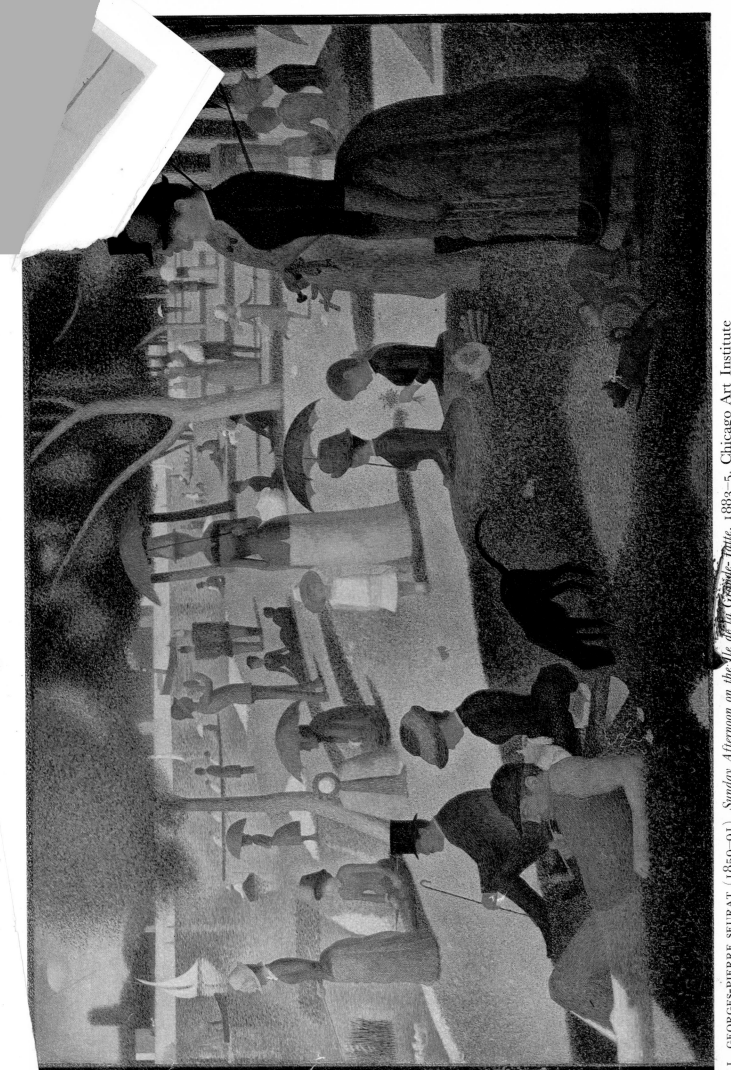

11. GEORGES-PIERRE SEURAT (1859–91). *Sunday Afternoon on the Ile de la Grande-Jatte*. 1883–5. Chicago Art Institute

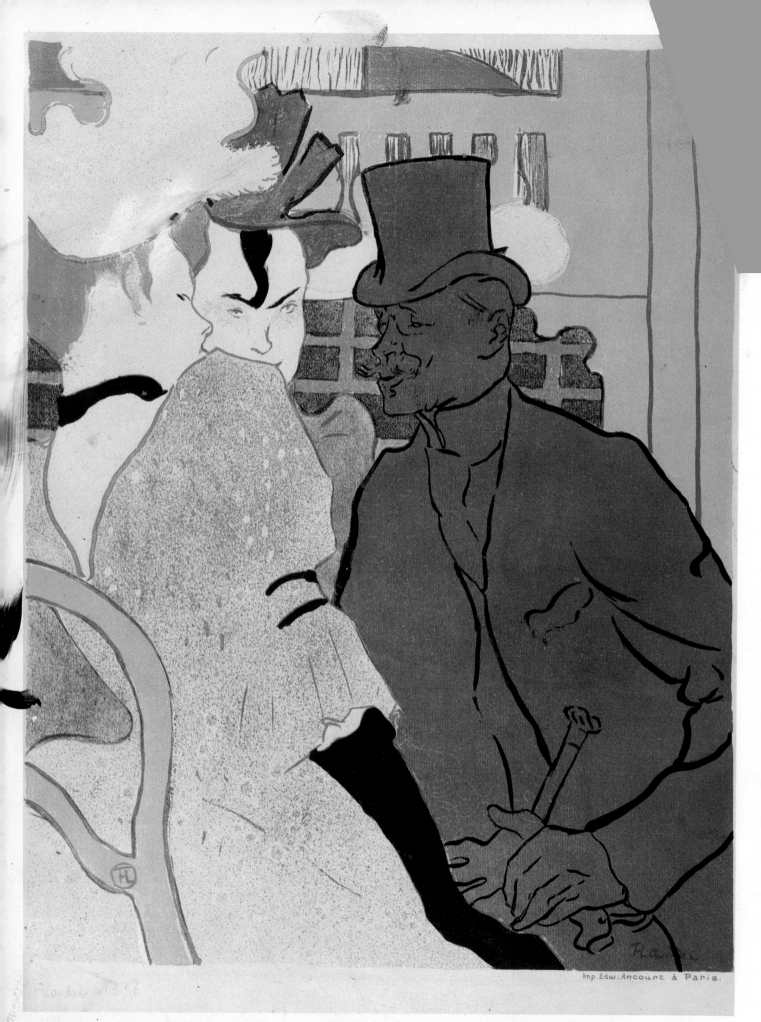

12. HENRI DE TOULOUSE-LAUTREC (1864–1901). *The Englishman at the Moulin Rouge.* 1892.
Coloured Lithograph

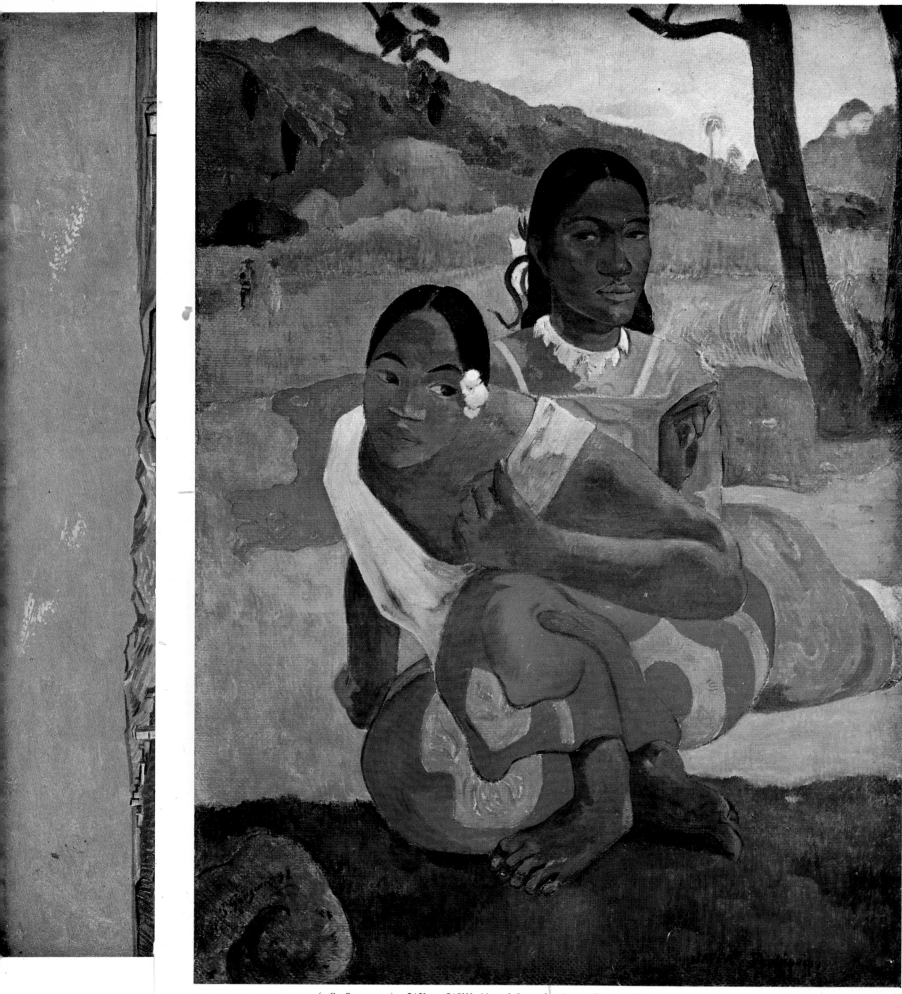

13. PAUL GAUGUIN (1848–1903). *When Will You Marry?* 1892. Basle, Kunstmuseum

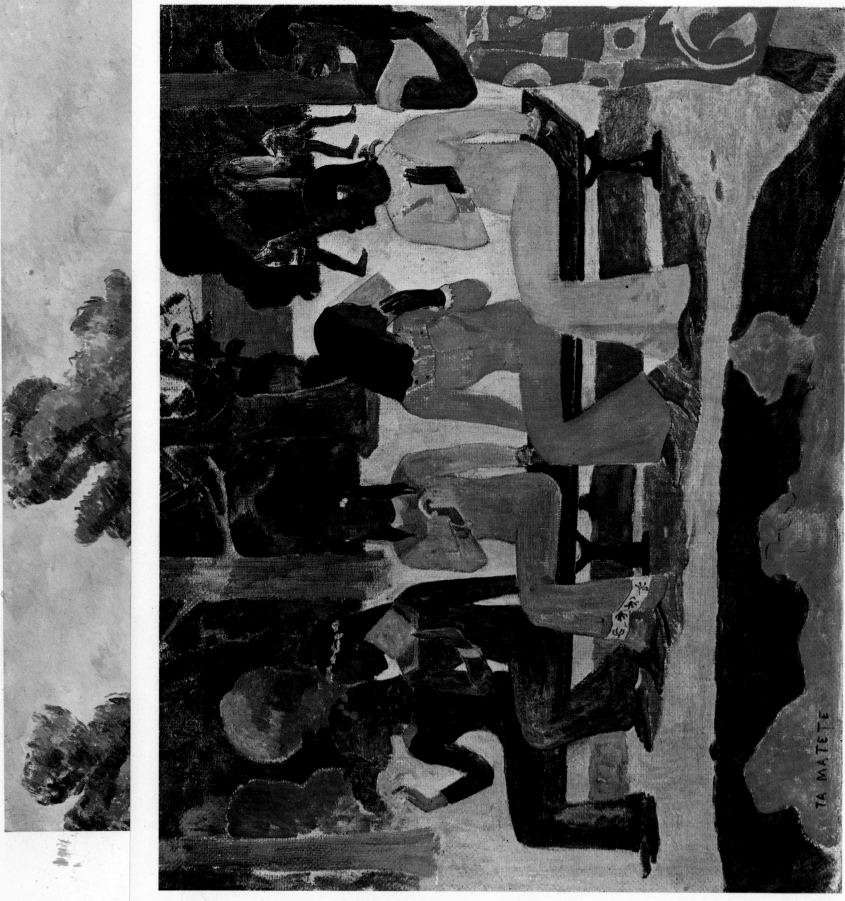

TA MATETE

16. PAUL GAUGUIN (1848–1903). *The Market*. 1892. Basle, Kunstmuseum

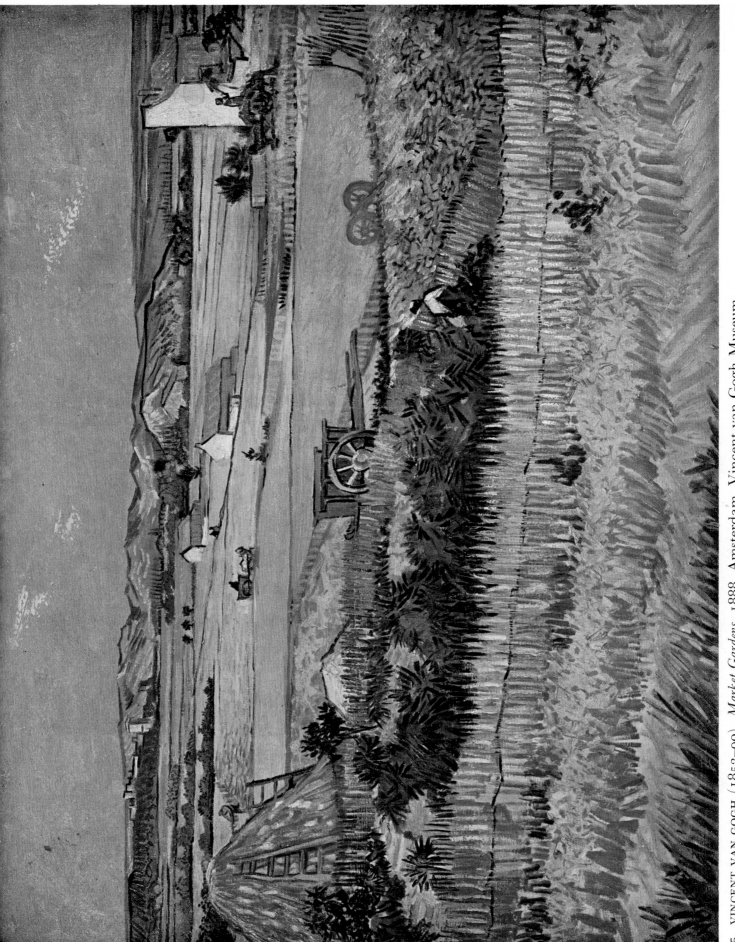

15. VINCENT VAN GOGH (1853—90). *Market Gardens.* 1888. Amsterdam, Vincent van Gogh Museum

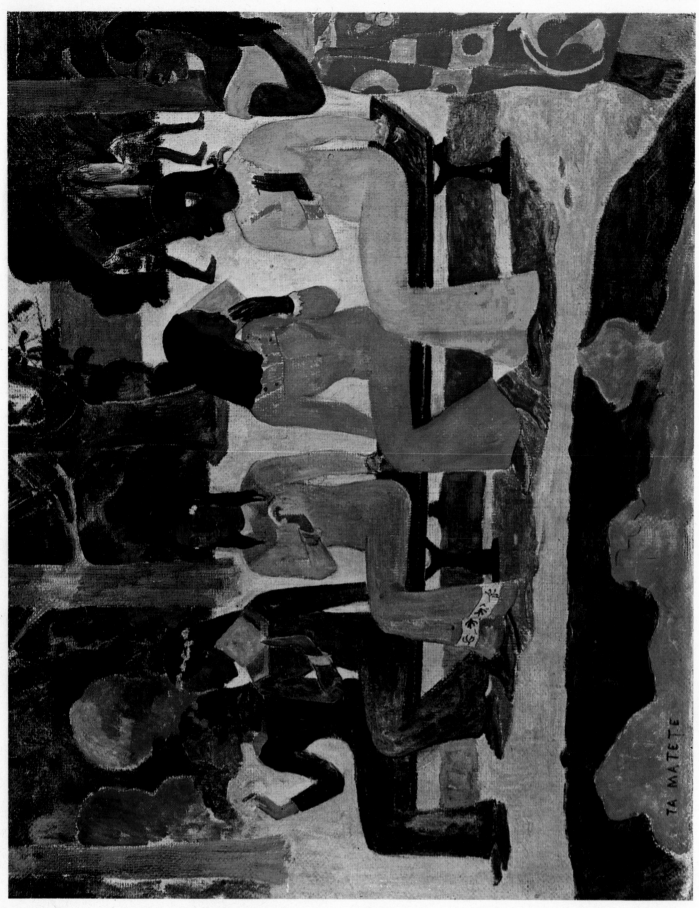

TA MATETE

16. PAUL GAUGUIN (1848–1903). *The Market*. 1892. Basle, Kunstmuseum

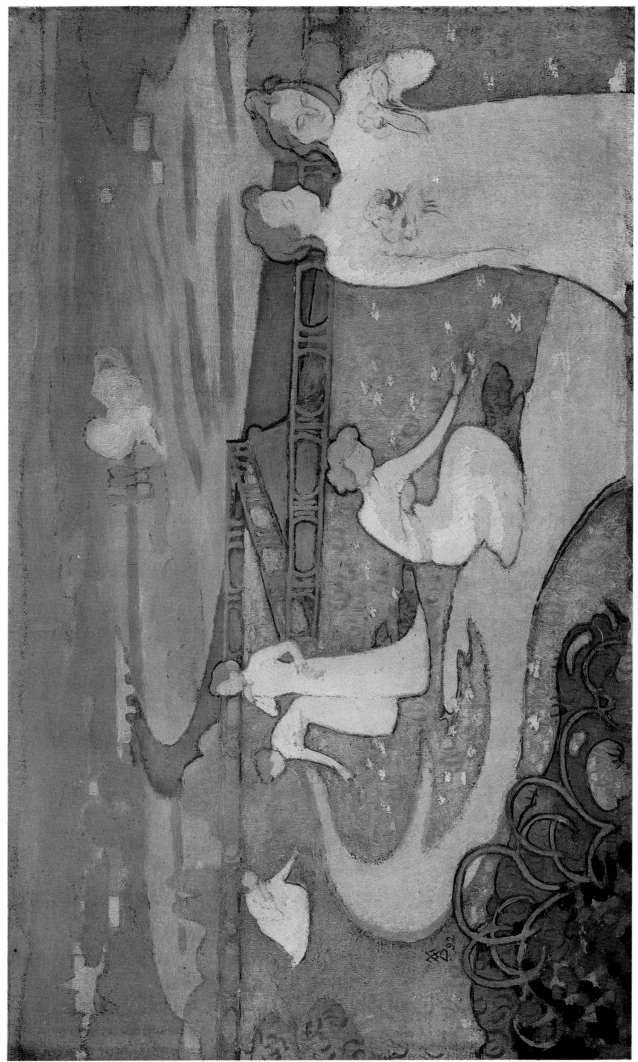

17. MAURICE DENIS (1870–1943). *April.* 1892. Otterlo, Rijksmuseum Kröller-Müller

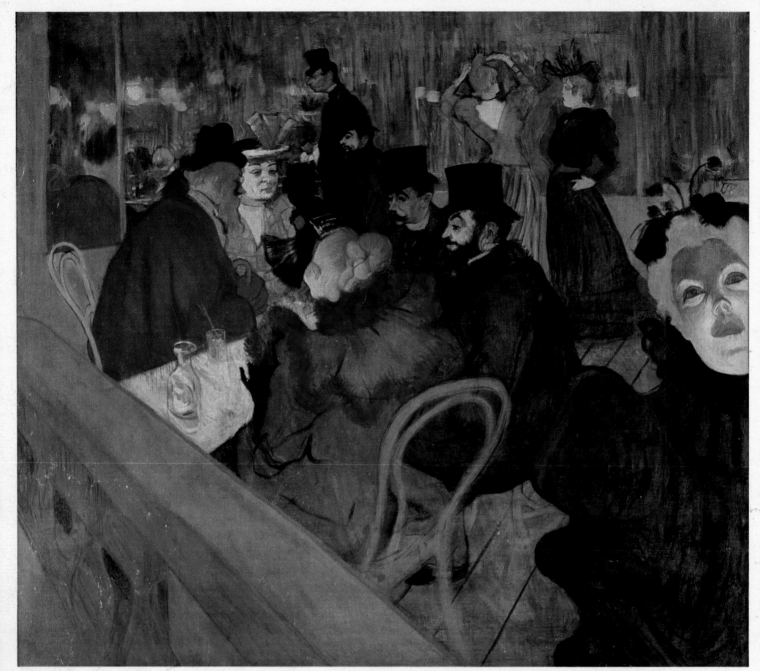

18. HENRI DE TOULOUSE-LAUTREC (1864–1901). *At the Moulin Rouge*. 1892. Chicago Art Institute (Helen Birch Bartlett Memorial Collection)

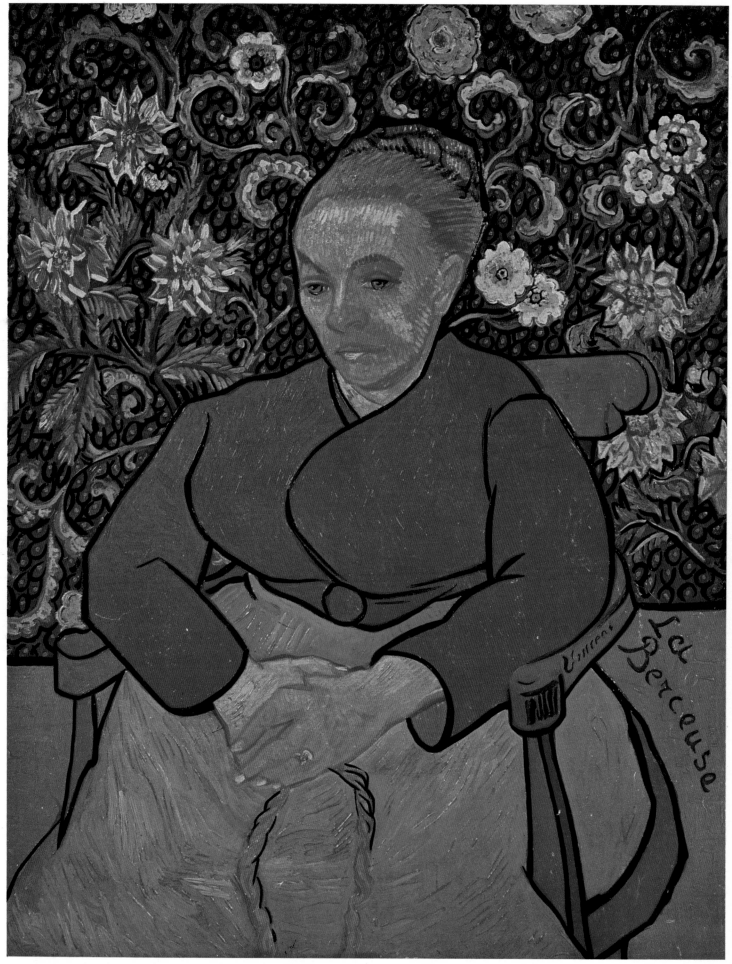

19. VINCENT VAN GOGH (1853–90). 'La Berceuse' (Mme. Roulin). 1889. Otterlo,
Rijksmuseum Kröller-Müller

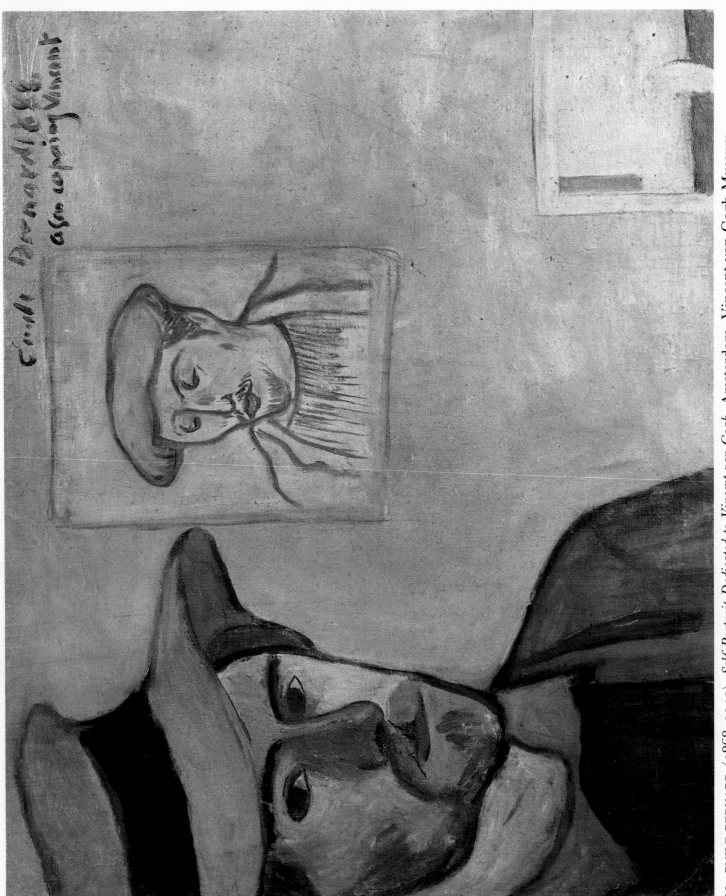

20. EMILE BERNARD (1868–1941). *Self-Portrait Dedicated to Vincent van Gogh*. Amsterdam, Vincent van Gogh Museum

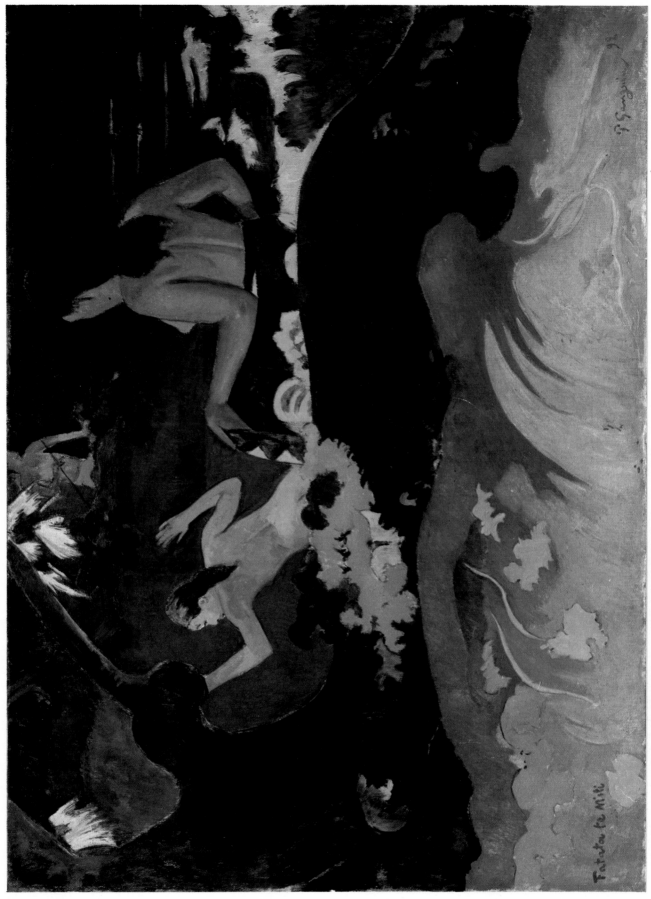

21. PAUL GAUGUIN (1848–1903). *Near the Sea.* 1892. Washington DC, National Gallery of Art (Chester Dale Collection)

22. GEORGES-PIERRE SEURAT (1859–91). *The Bridge at Courbevoie*. 1886–7. London, Courtauld Institute

23. GEORGES-PIERRE SEURAT (1859–91). *Sunday at Port-en-Bessin.* 1888. Otterlo, Rijksmuseum Kröller-Müller

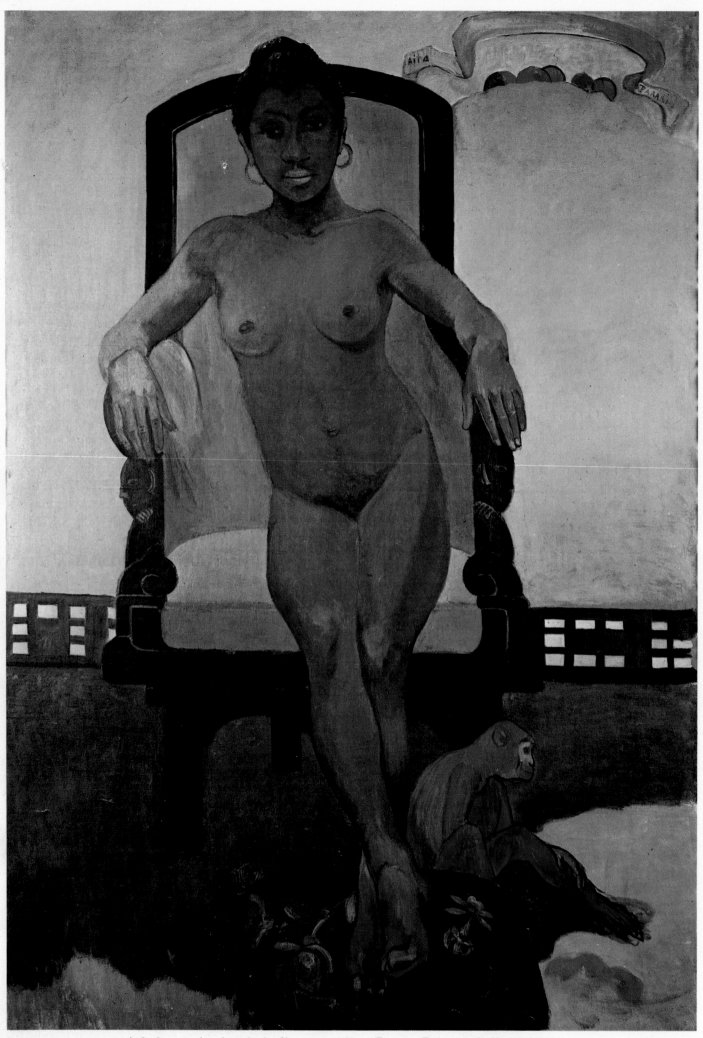

24. PAUL GAUGUIN (1848–1903). *Annah the Javanese*. 1893. Berne, Private Collection

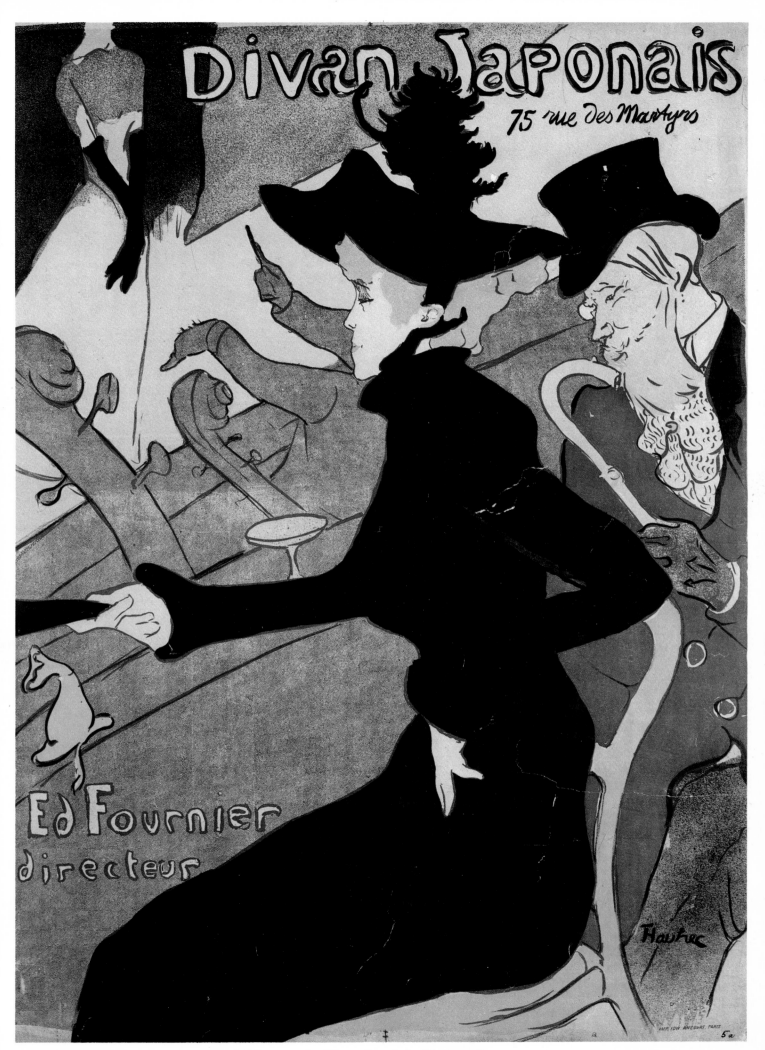

25. HENRI DE TOULOUSE-LAUTREC (1864–1901). *Divan Japonais*. Poster, 1893

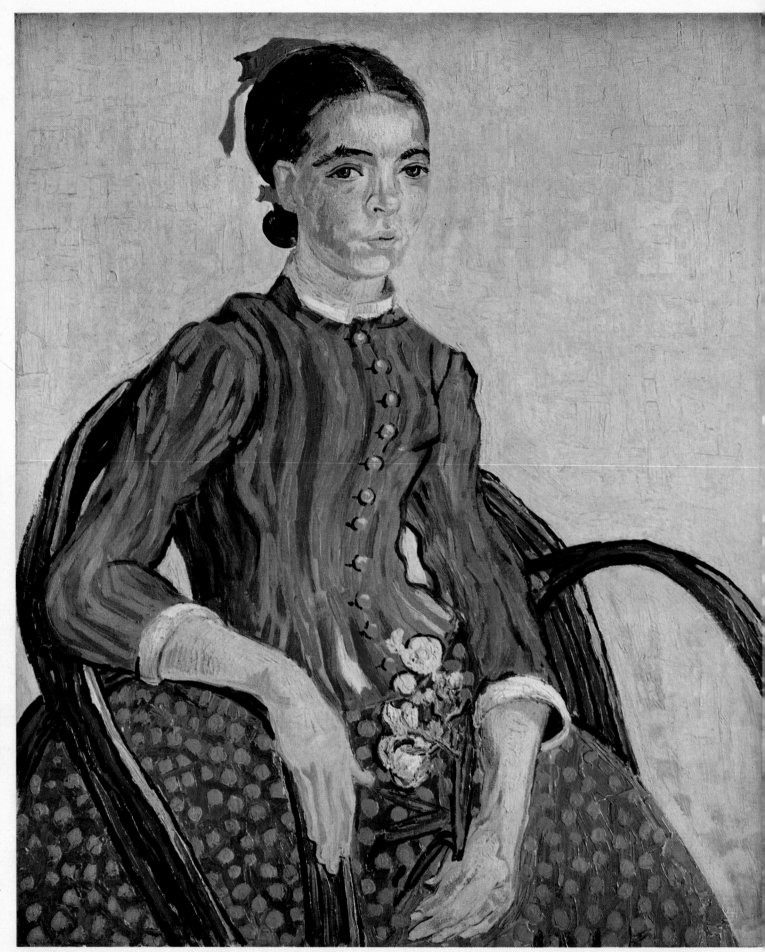

26. VINCENT VAN GOGH (1853–90). *La Mousmé*. 1888. Washington DC, National Gallery of Art (Chester Dale Collection)

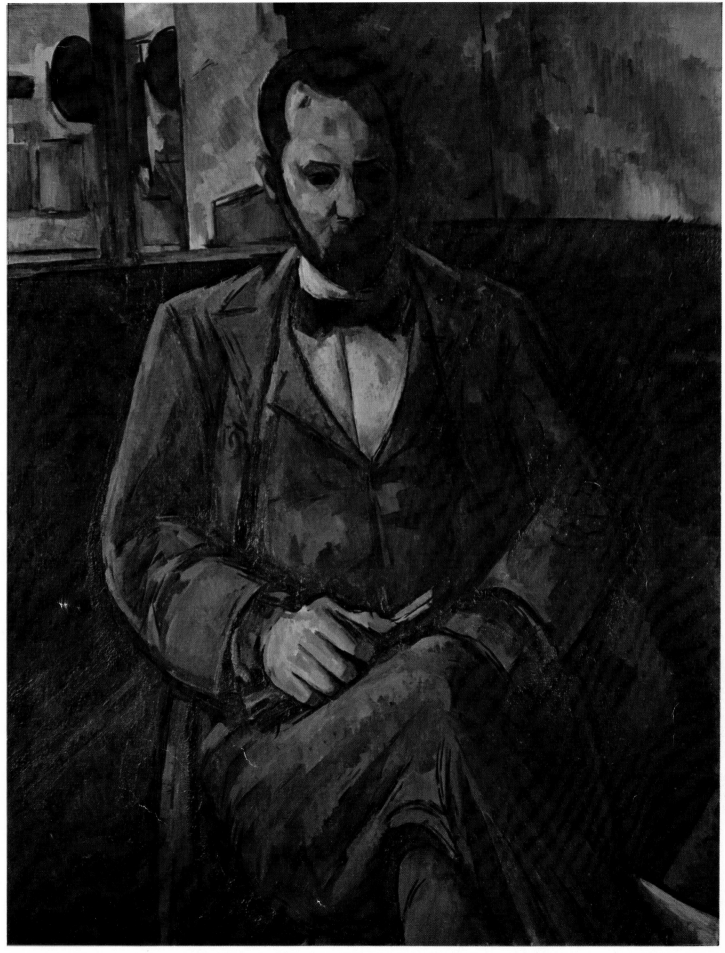

27. PAUL CÉZANNE (1839–1906). *Portrait of Ambrose Vollard*. 1899. Paris, Louvre

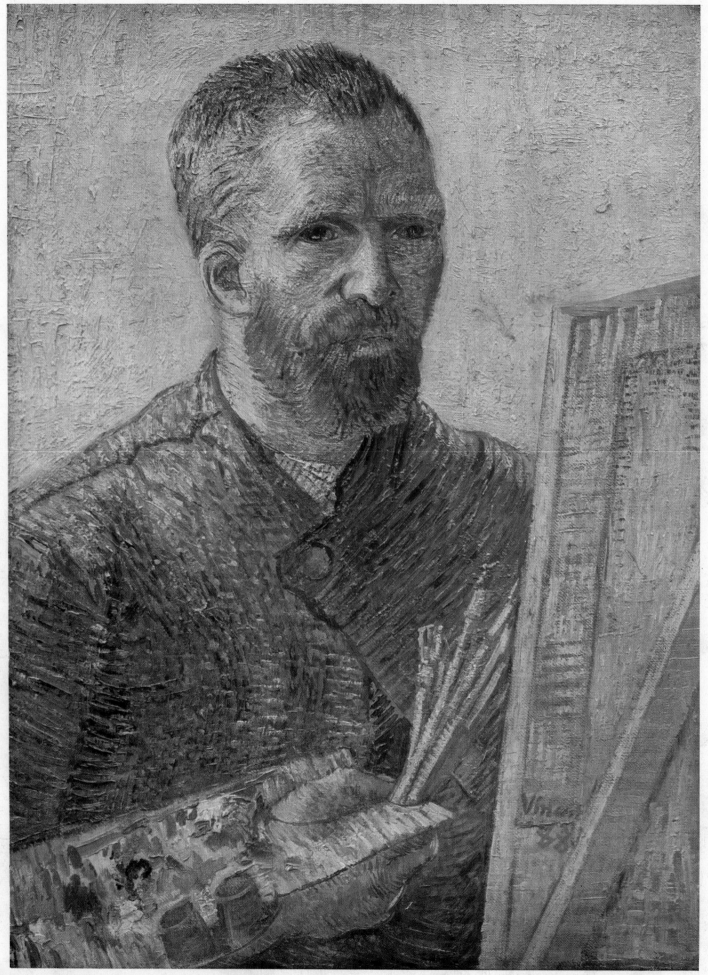

28. VINCENT VAN GOGH (1853–90). *Self-portrait*. 1888. Amsterdam, Vincent van Gogh Museum

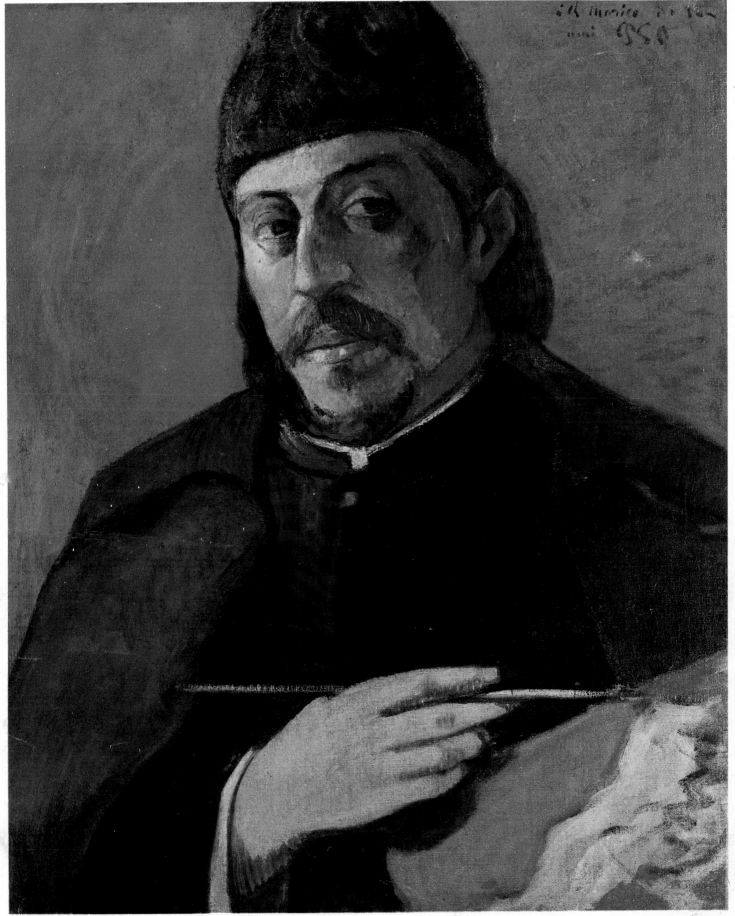

29. PAUL GAUGUIN (1848–1903). *Self-portrait with Palette.* 1893. Los Angeles, Mr & Mrs Norton Simon

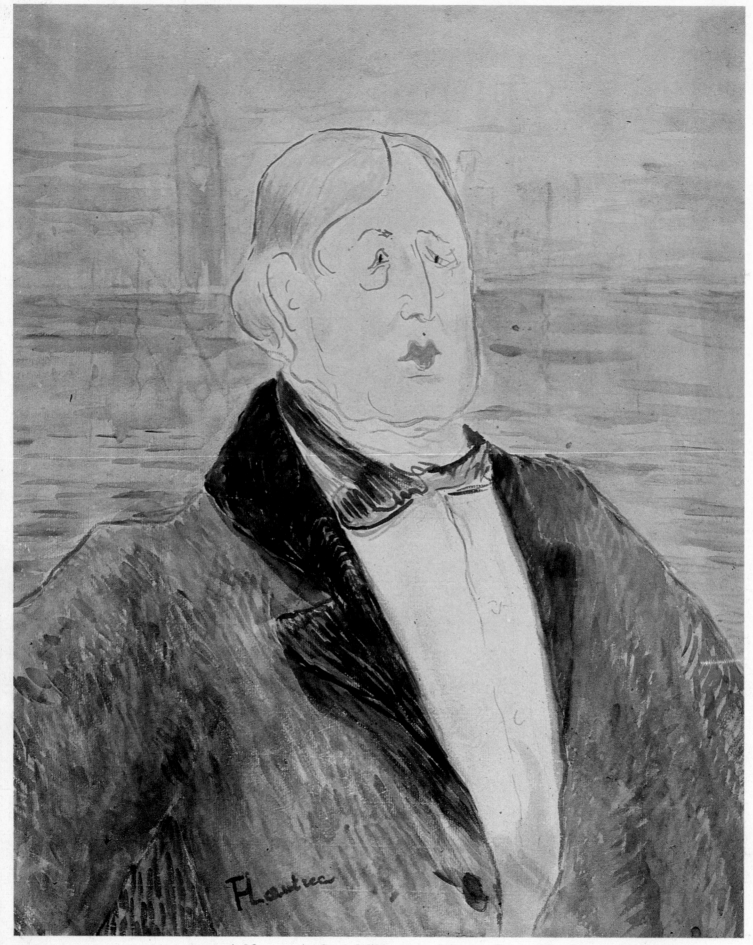

30. HENRI DE TOULOUSE-LAUTREC (1864–1901). *Oscar Wilde*. 1895. Vienna, Dr & Mrs Conrad H. Lester

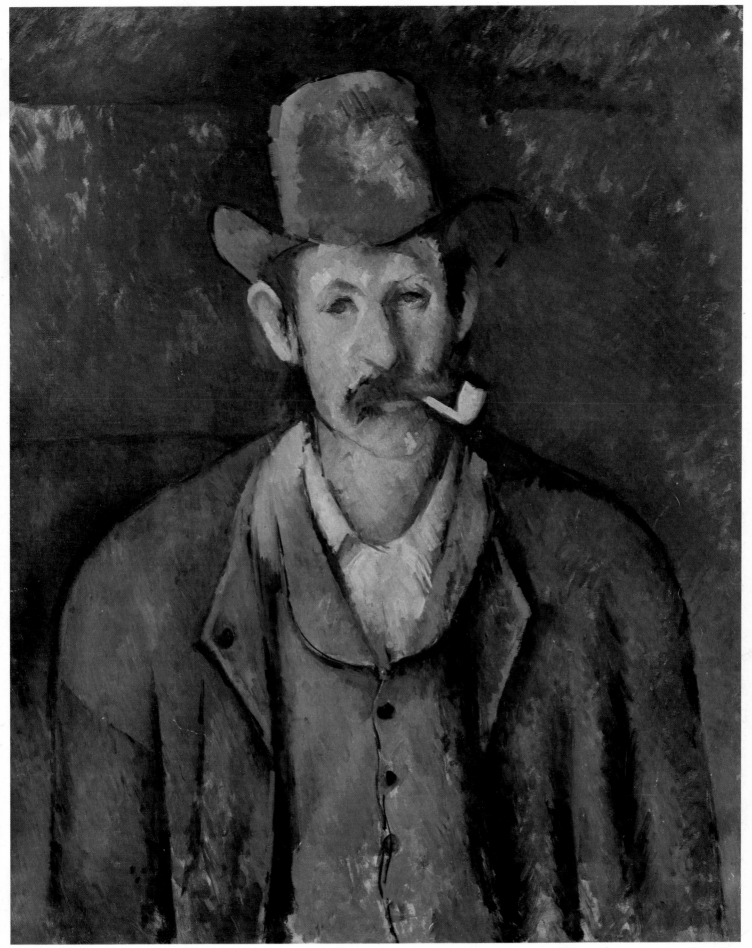

31. PAUL CÉZANNE (1839–1906). *Man Smoking a Pipe*. About 1892. London, Courtauld Institute

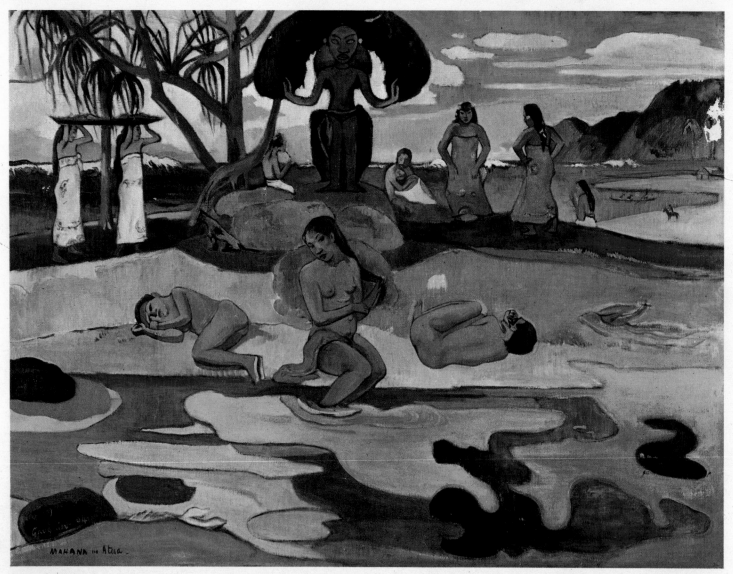

32. PAUL GAUGUIN (1848–1903). *The Day of God.* 1894. Chicago Art Institute (Helen Birch Bartlett Memorial Collection)

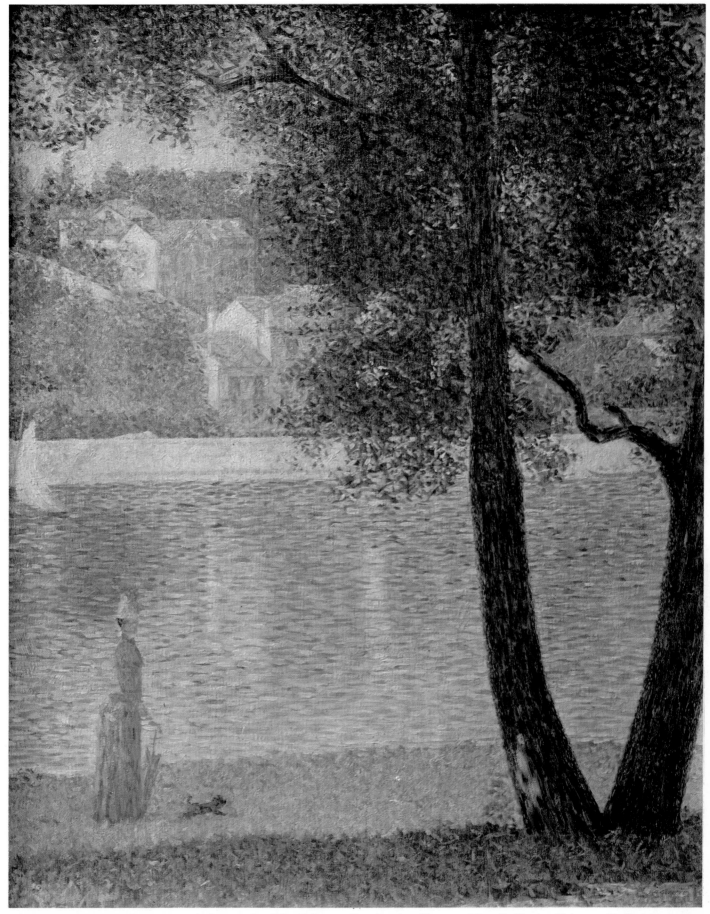

33. GEORGES-PIERRE SEURAT (1859–91). *The Seine at Courbevoie*. About 1885–6. Paris, Private Collection

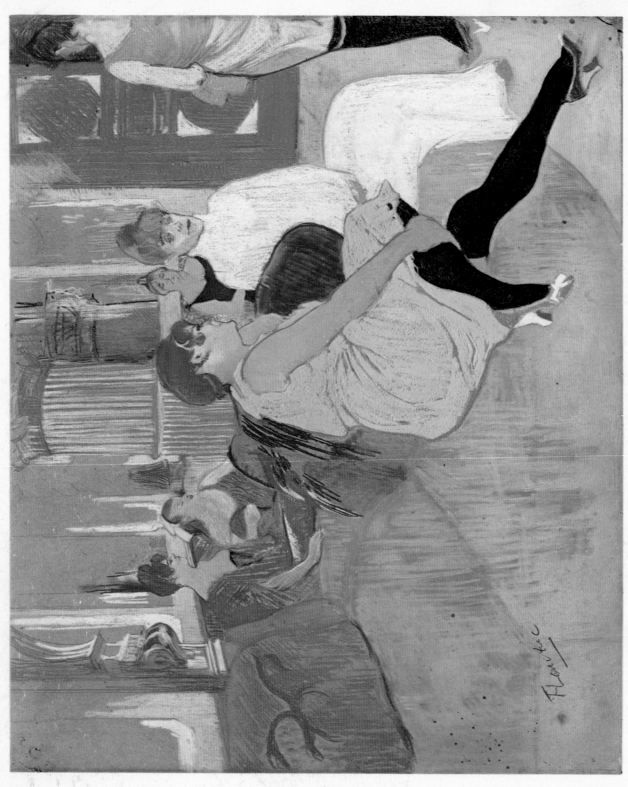

34. HENRI DE TOULOUSE-LAUTREC (1864–1901). *Salon in the Rue des Moulins*. 1894. Albi, Musée Toulouse-Lautrec

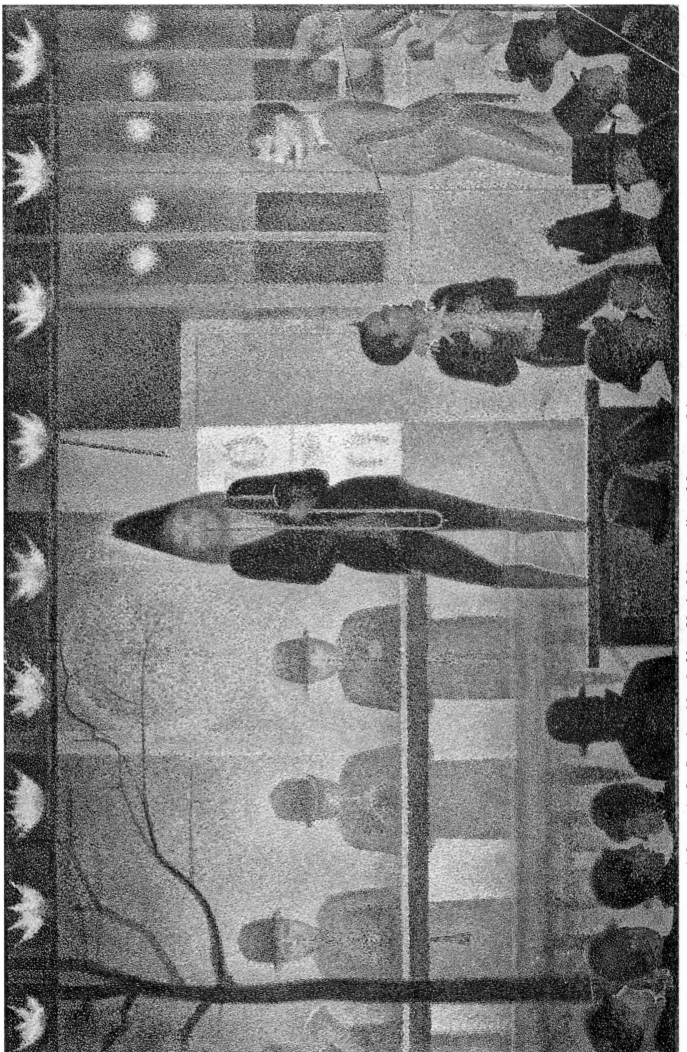

35. GEORGES-PIERRE SEURAT (1859–91). *La Parade*. 1887–8. New York, Metropolitan Museum of Art

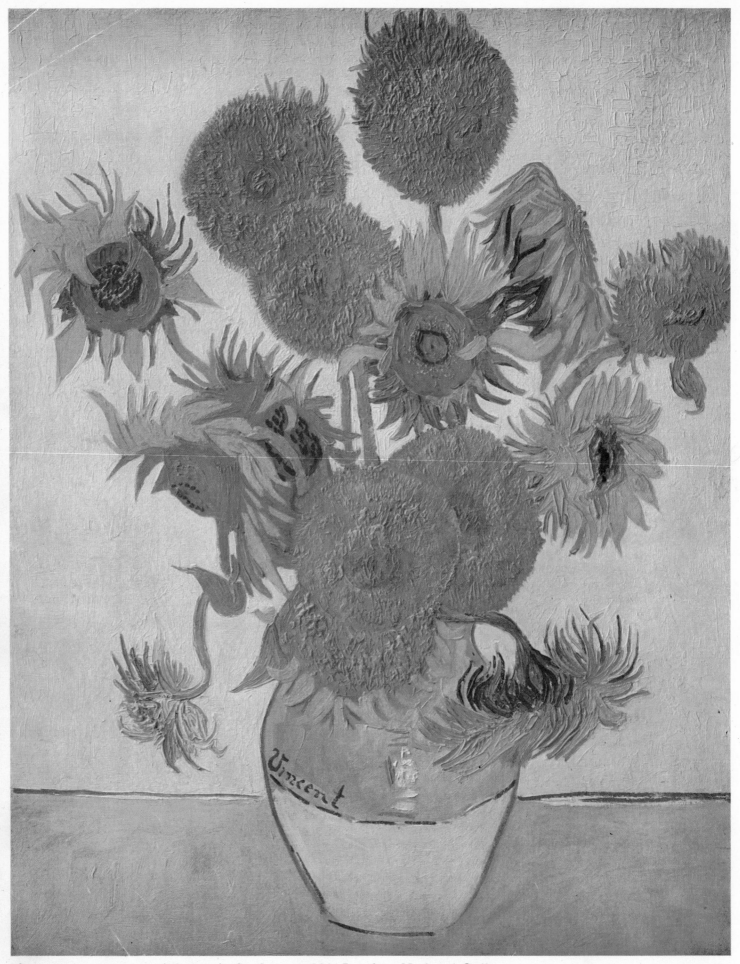

36. VINCENT VAN GOGH (1853–90). *Sunflowers*. 1888. London, National Gallery

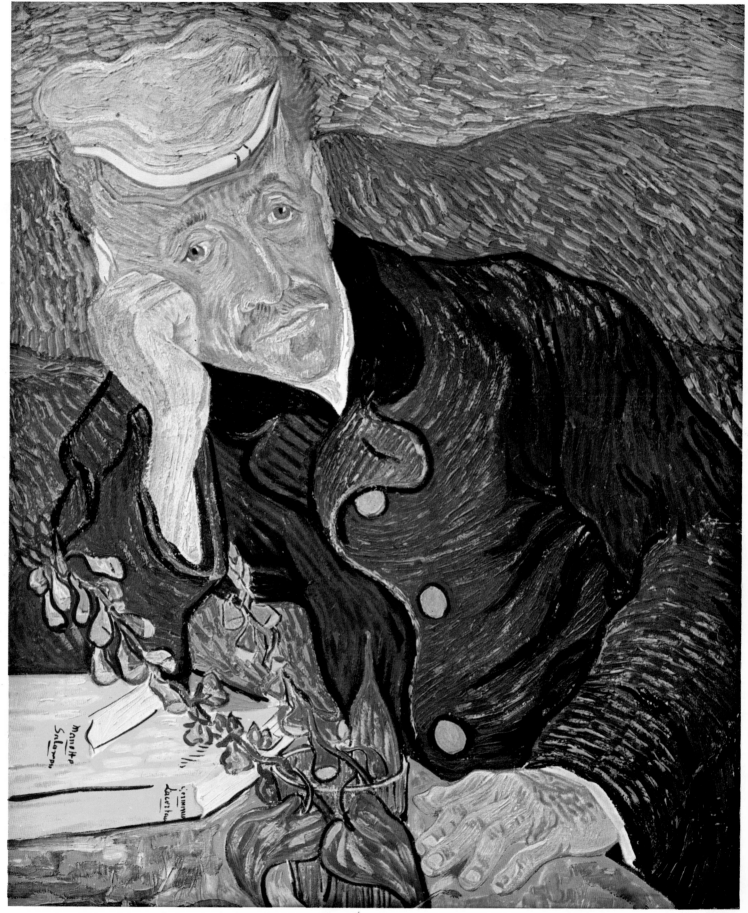

37. VINCENT VAN GOGH (1853–90). *Dr. Gachet*. 1890. New York, S. Kramarsky Trust Fund

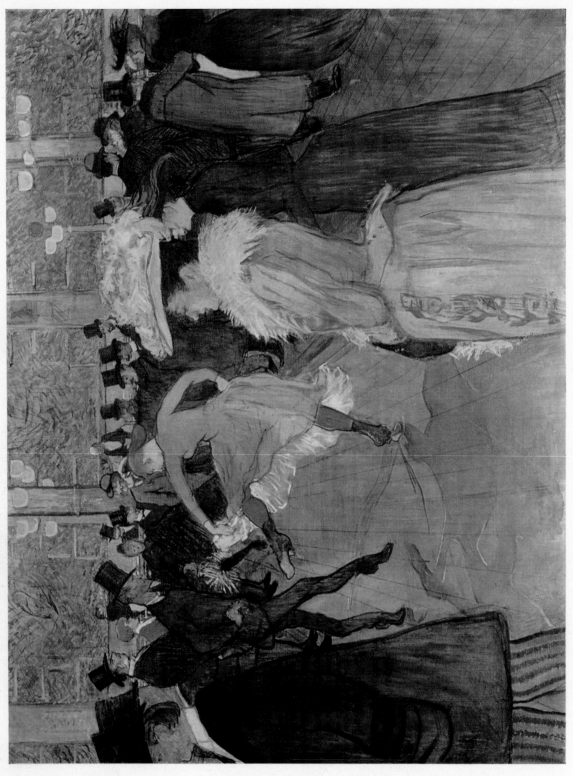

38. HENRI DE LA TOULOUSE-LAUTREC (1864–1901). *Dance at Moulin Rouge*. 1890. Philadelphia, Henry McIlhenny

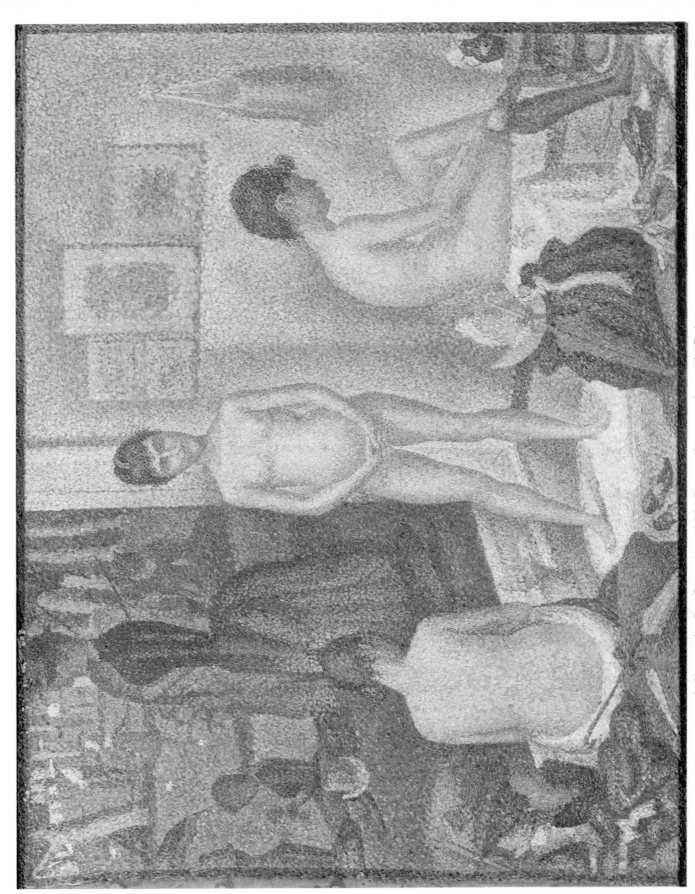

39. GEORGES-PIERRE SEURAT (1859–91). *Les Poseuses*. 1888. Luxembourg, Artemis S.A.

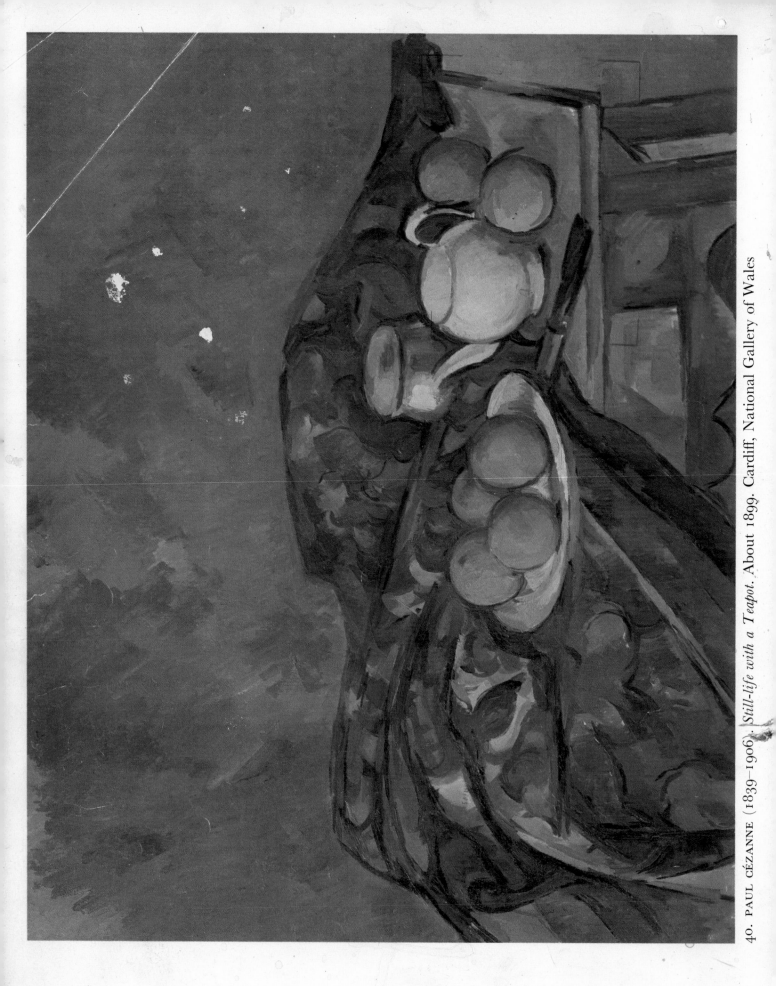

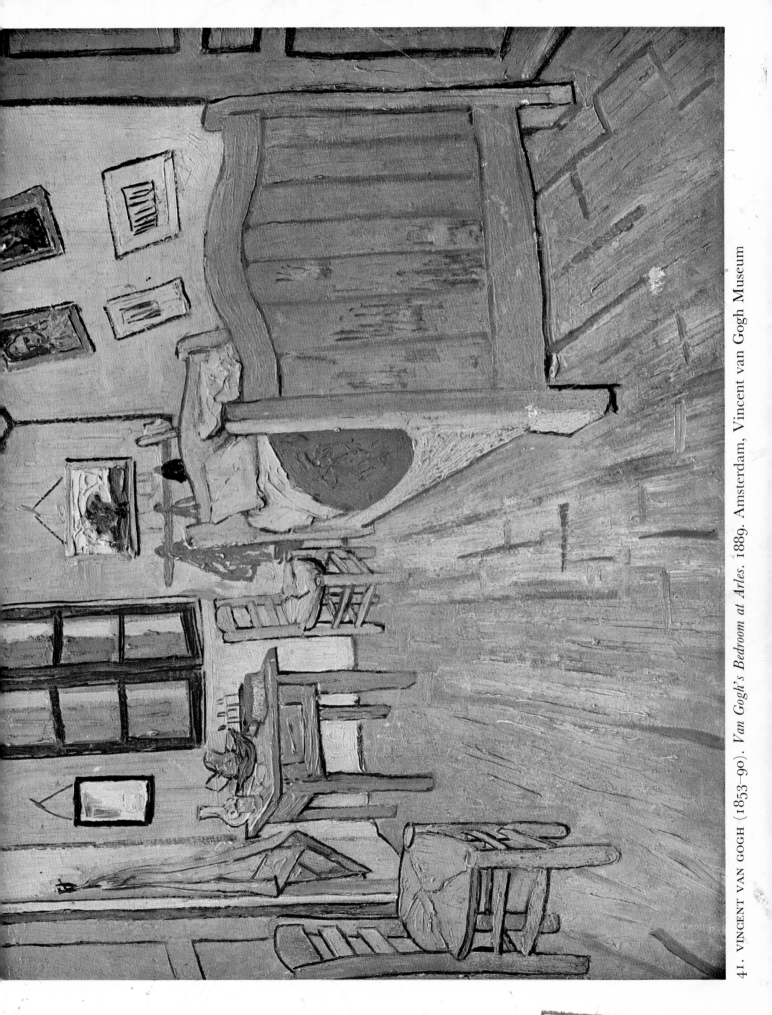

41. VINCENT VAN GOGH (1853–90). *Van Gogh's Bedroom at Arles.* 1889. Amsterdam, Vincent van Gogh Museum

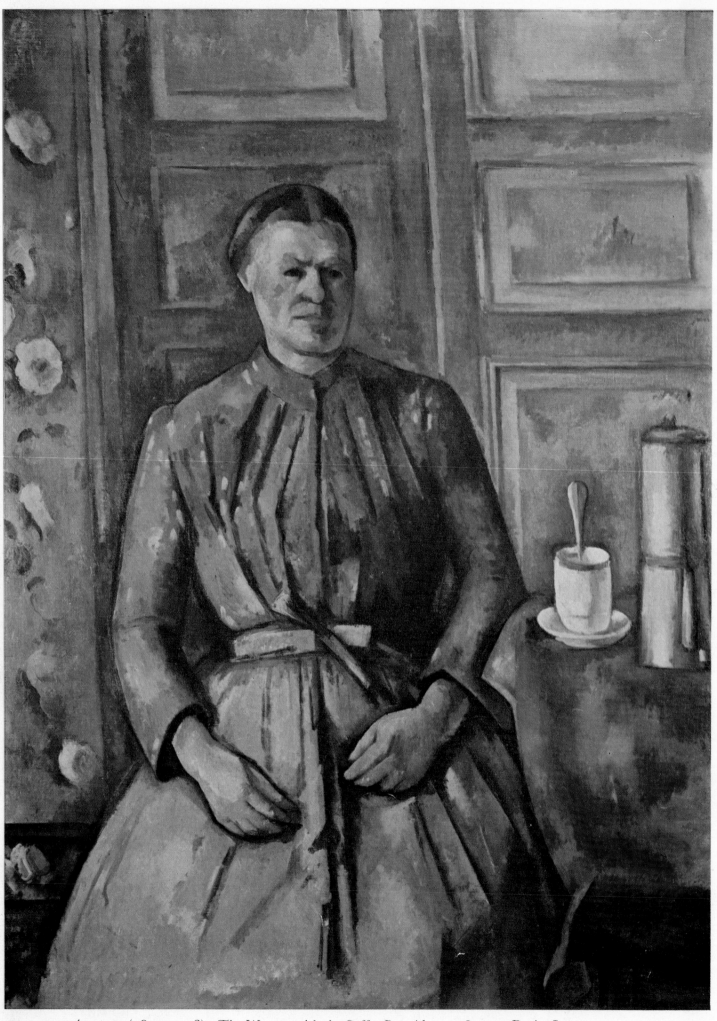

42. PAUL CÉZANNE (1839–1906). *The Woman with the Coffee Pot*. About 1890–4. Paris, Louvre

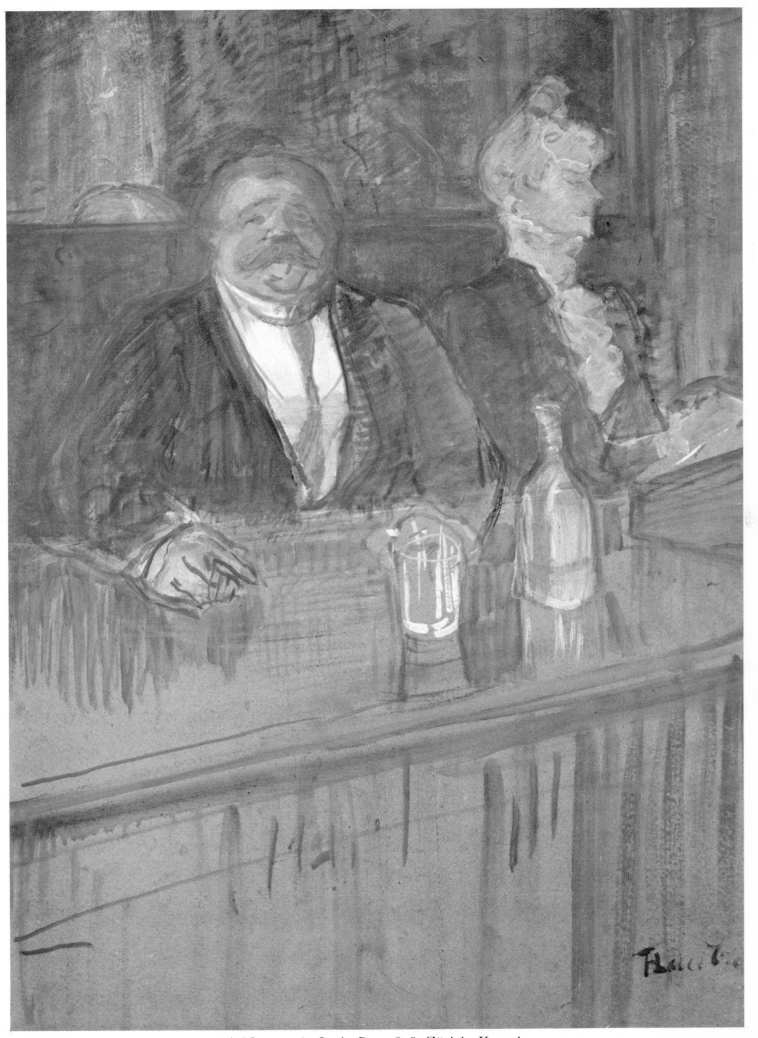

43. HENRI DE TOULOUSE-LAUTREC (1864–1901). *In the Bar*. 1898. Zürich, Kunsthaus

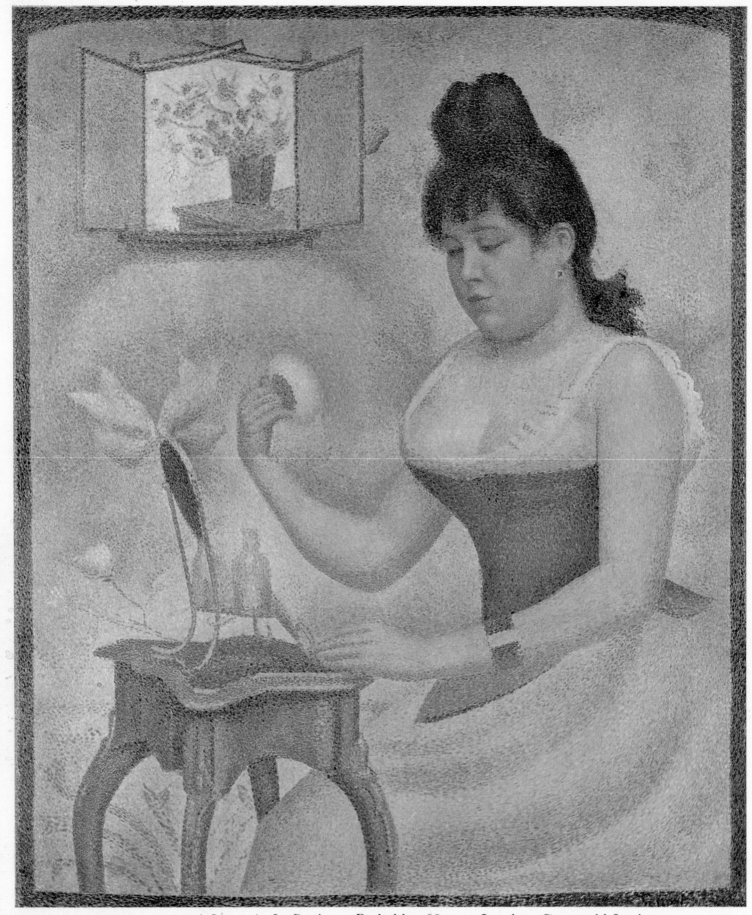

44. GEORGES-PIERRE SEURAT (1859–91). *La Poudreuse*. Probably 1889–90. London, Courtauld Institute

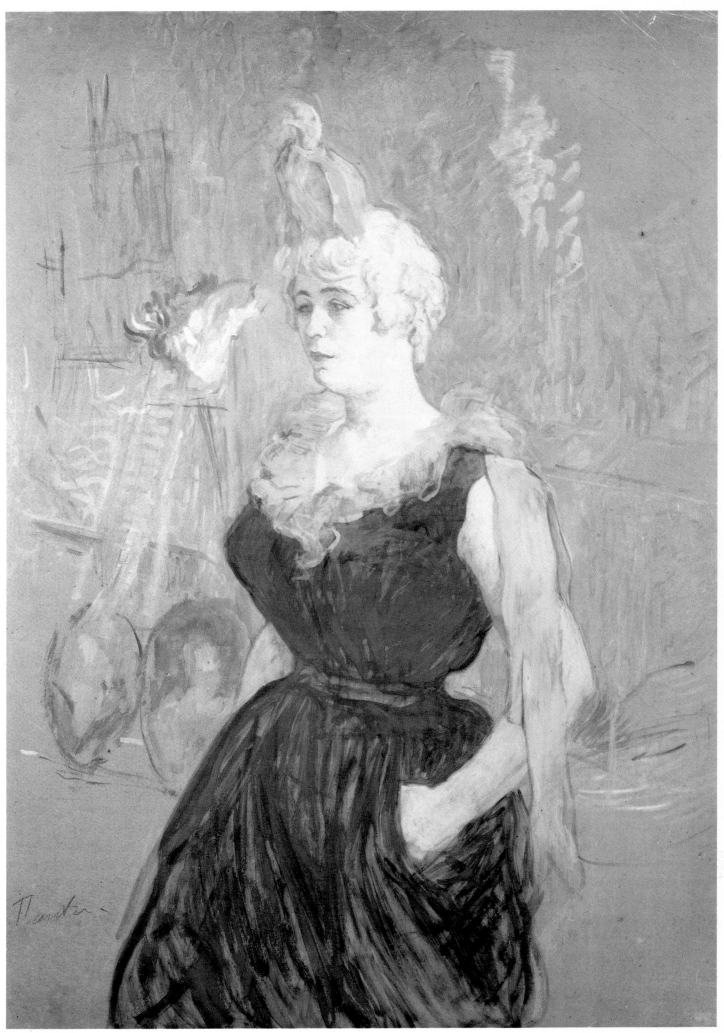

45. HENRI DE TOULOUSE-LAUTREC (1864–1901). *Clowness Cha-u-ka-o*. 1895. Cannes, Mrs Frank J. Gould

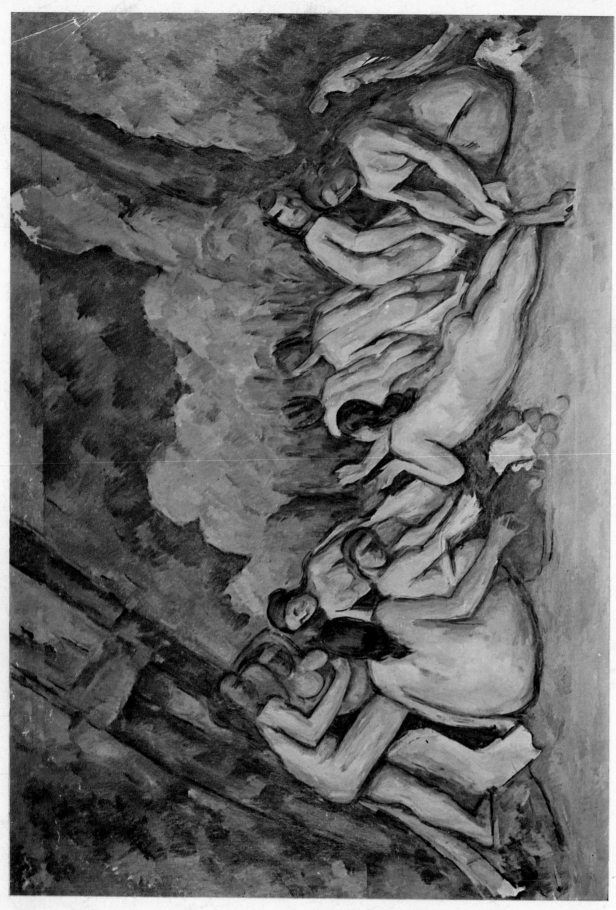

46. PAUL CÉZANNE (1839–1906). *Bathing Women. About 1900–5*. London, National Gallery

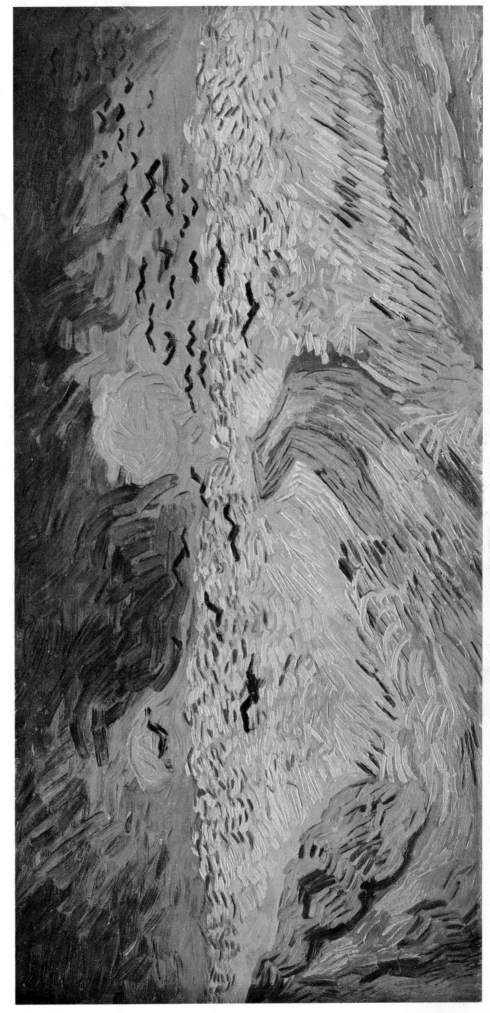

47. VINCENT VAN GOGH (1853–90). *Crows over a Cornfield*. 1890. Amsterdam, Vincent van Gogh Museum

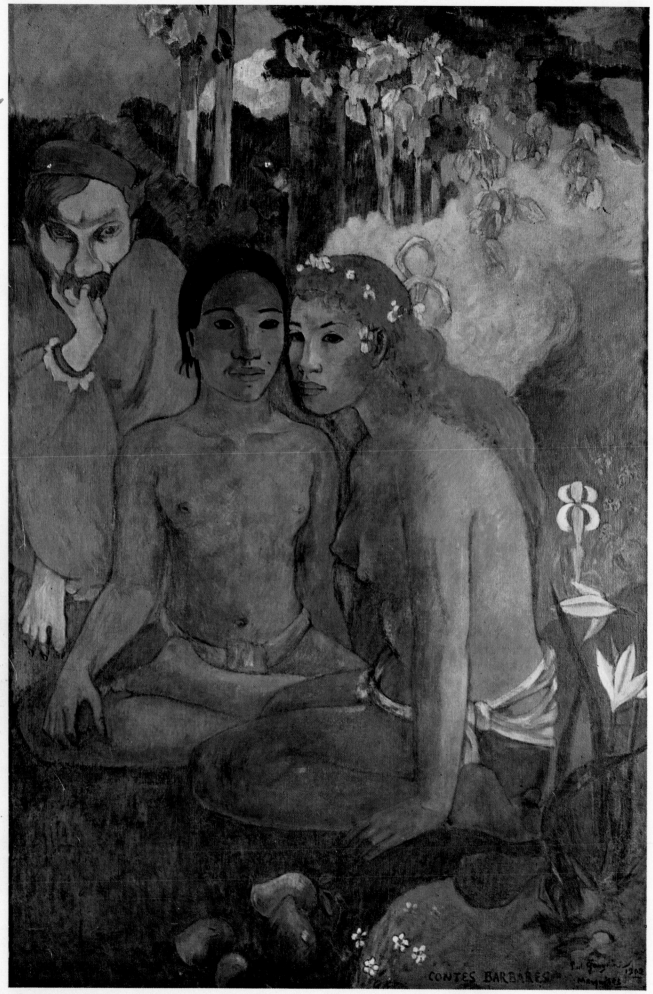

48. PAUL GAUGUIN (1848–1903). *Contes Barbares*. 1902. Essen, Folkwang Museum